IMAGES
of America

EARLY GLENWOOD
SPRINGS

On the Cover: Three unidentified bathing beauties pose under the arbor alongside the Hot Springs Pool in Glenwood Springs around 1915. Their attire is typical of the time period—a wool or cotton bathing costume covering the upper arms and a skirt falling below the knees. Tights (to cover the legs and feet) and a bathing cap or turban completed the outfit.

IMAGES of America
EARLY GLENWOOD SPRINGS

Cynthia Hines and the Frontier Historical Society

Copyright © 2015 by Cynthia Hines and the Frontier Historical Society
ISBN 978-1-4671-3297-8

Published by Arcadia Publishing
Charleston, South Carolina

Printed in the United States of America

Library of Congress Control Number: 2014959613

For all general information, please contact Arcadia Publishing:
Telephone 843-853-2070
Fax 843-853-0044
E-mail sales@arcadiapublishing.com
For customer service and orders:
Toll-Free 1-888-313-2665

Visit us on the Internet at www.arcadiapublishing.com

To the historians who have come before—your passion and dedication have created a legacy that will inspire others to follow in your footsteps.

CONTENTS

Acknowledgments		6
Introduction		7
1.	A Vision of Prosperity	9
2.	A Health Resort Is Born	21
3.	Building a Town	43
4.	Bring in the Tourists	77
5	(In)famous Residents and Visitors	95
6.	Recreation, Events, and Celebrations	109
About the Frontier Historical Society		127

Acknowledgments

The publication of this book would not have been possible without the collections and archives of the Frontier Historical Society and Museum in Glenwood Springs. I want to acknowledge the local authors who have gathered the history before me. First and foremost, thank you, Willa Soncarty Kane, for your extensive research as a former archivist and in writing your newspaper columns—"Time and Again" (for the *Glenwood Post*) and "Frontier Diary" (for the *Glenwood Springs Post Independent*)—on behalf of the Frontier Historical Society. Your work made this project possible.

I would also like to recognize Lena Urquhart, Jim Nelson, and Angela and Don Parkison. Your books have been great sources of reference for writing the captions for the images included in this publication.

Thank you to my staff, Patricia Stark and Sue Plush, and to the current members of my board of directors for supporting this project. All of the images in this book appear courtesy of the Frontier Historical Society and Museum.

INTRODUCTION

The Glenwood Springs area of western Colorado, with its bubbling hot springs, has long been a destination for the health-seeker. It was originally inhabited by nomadic Ute tribes who traveled to the area to partake of the hot springs for many years before they were forced onto reservation lands in eastern Utah in 1881.

Nearly six years before Glenwood Springs was incorporated in August 1885, pioneer James Landis came to the valley in search of meadow hay to cut and haul back to Leadville, Colorado, for animal feed. Landis found the valley so enchanting that he returned the following spring to make a claim on a homestead.

At the same time, Capt. Isaac Cooper entered the area from Aspen, seeking relief in the hot springs for ailments he contracted during the Civil War. The hot springs did indeed bring relief to Cooper—so much so that he envisioned a resort area built around them and "sharing their miracle healing with the ill of the entire world." In 1882, Cooper purchased Landis's homestead, which contained the hot springs, for $1,500. Although Cooper's dream of creating a spa for the world fell short (only 100 settlers arrived in the three years after he purchased the land), he planted the seeds for a community and business district that have been growing ever since. Walter Devereux and his Colorado Land and Improvement Company made Cooper's dream a reality when they constructed the Hot Springs Pool (in 1888) and Hotel Colorado (in 1893) near the area hot springs.

Many of the first businesses in Glenwood Springs operated out of tents and wooden-frame buildings, including Blake & Putman General Merchandise, the Kamm and Schram groceries, Pat Carr's saloon, and the Barlow Hotel. A Mrs. Thomas operated a laundry near the hot springs, utilizing the naturally heated water, while a Dr. Baldwin dispensed drugs from a covered wagon.

Riverfront (Seventh) Street and Cooper Avenue were the first main thoroughfares, although as more substantial buildings rose along Grand Avenue, it gradually became the main street. Most of the downtown buildings constructed around this time still survive.

One of the most impressive structures, the Hotel Glenwood, was completed in 1886. Considered one of the most lavish hotels on the western slope, it operated continually until a devastating fire destroyed the hotel in 1945. Two banks—Glenwood National Bank and First National Bank—opened their doors in 1887.

Complementing the business district, the natatorium and (hot springs) pool were completed on the opposite bank of the Grand (Colorado) River in 1888, while the stone bathhouse was completed in 1890. The completion of two major railroad lines—the Denver & Rio Grande and the Colorado Midland—not only facilitated the transport of coal back to the Front Range but also encouraged tourist travel to the area.

The citizens of Glenwood Springs celebrated several highlights in the 1890s. The bridge designed by Theodore Von Rosenberg, which connected the north bank to Grand Avenue across the Grand River, was dedicated on April 25, 1891; the Hotel Colorado was completed in 1893; and the first Strawberry Day (now Strawberry Days) festival was held in 1898. Although the Silver Panic of 1893 devastated many communities throughout the mountains of Colorado, it did not have a great effect on the tourist economy of Glenwood Springs, and the town continued to grow rapidly.

The early days of the 20th century brought new buildings and organizations to Glenwood Springs. Businesses were prospering, and Horace Devereux promoted the organization of a board of trade (a precursor to the chamber of commerce). The Denver & Rio Grande depot was completed, as was Garfield County High School. Although the depot is still standing today, the high school building is not. For many people, the most significant highlight from the first decade of the 20th century was Theodore Roosevelt's visit to the area in April 1905.

The 1910s began with the appearance of Halley's Comet in the night sky; tours heading up Lookout Mountain were very popular. In 1910, Glenwood Springs hailed the delivery and purchase of the first seven Ford automobiles. Modernization continued when the Hotel Colorado traded its horse and buggy for an electric bus to convey people back and forth across the river. During this time, the Garfield County Commissioners officially renamed the Grand River Canyon "Glenwood Canyon."

After growing up in Glenwood Springs and having had the good fortune to be employed as the executive director of the Frontier Historical Society and Museum for the past 15 years, I was in an advantageous position to create this book. The Frontier Historical Society has over 5,000 photographic images in its collection that I was able to draw from. We also have the largest research archives in Garfield County. I chose to introduce each chapter with an actual quotation from the relevant time period, which gives the reader a sense of what was important enough at the time to be included in letters, newspapers, and public speeches. Another reason for using quoted material is to show readers how people wrote and spoke back then, which was very different from how we communicate today.

One subject that may be appropriate to cover in the future is coal mining, which was a large part of Glenwood Springs' economy. With coal mines stretching from New Castle to Carbondale, Glenwood became a retail hub for goods used to supply mining camps. The Cardiff Coke Ovens, located south of town, were used to cook raw coal, burning out the impurities and making the coal suitable for use in smelters. I have also chosen to exclude, for now, chapters on the 1930s and 1940s illustrating the days when the Glenwood Springs was home to a Civilian Conservation Corps (CCC) camp and a World War II prisoner-of-war camp, and when the Hotel Colorado and Hot Springs Pool were taken over by the Navy as a convalescent hospital for sailors.

While there were many wonderful photographic images I was unable to include, I hope that readers will enjoy the ones I have chosen for this journey through the early days of Glenwood Springs.

One

A Vision of Prosperity

A letter from the first resident of Glenwood Springs to his mother back in Kansas is transcribed here. James Landis encouraged his mother and siblings to join him at the hot springs he was homesteading and create a new life for their family. They eventually did join him, along with countless others who saw the potential for success in the fledgling town.

December 1, 1880

Dear Mother,

I received your kind letter yesterday. I am glad to hear that you are all well. I have located the Hot Springs (our own springs) on the Grand river, 70 miles west of here, and I am going to spend the winter there and build a house and fix up a home. I have some good mining interest near also. If you wish to live here, I would be glad to have you with me. I am yet a single man, no one to love or care for me except my respected mother.

You must not sacrifice your farm to come, but if you can dispose of it at a good figure please let me know, and if justifiable and your desire I will come home next April and fix up your business for you to make you a home here where there is a good chance for you to make money in the dairy and ranch business.

Milk is worth 40 to 60 cents per gallon, butter 50 cents per pound, hay 4 to 6 cents per pound, potatoes and onions 7 to 10 cents per pound. I have a splendid hay ranch and if you wish to come please let me know. So wishing you well I will conclude. I am your devoted son.

<div style="text-align:right">
J.M. Landis

Red Cliff,

Summit County,

Colorado
</div>

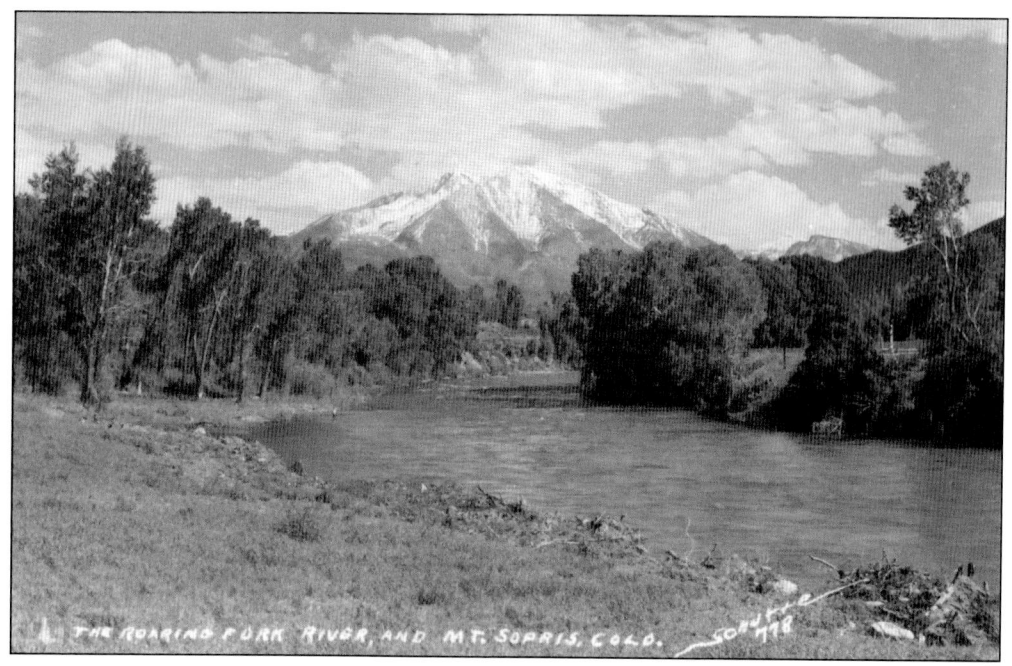

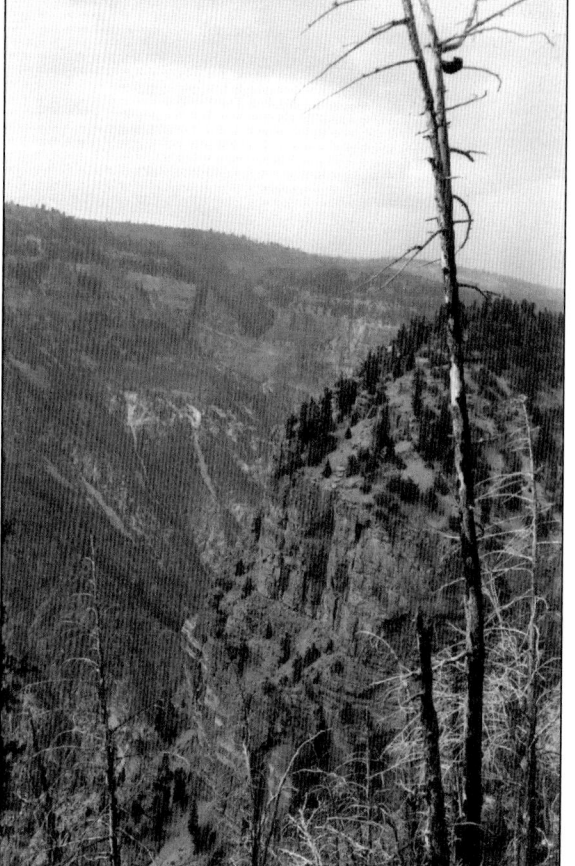

MOUNT SOPRIS. In July 1860, Richard Sopris led prospectors into western Colorado, where their expedition delivered them into the Roaring Fork Valley. The view of the spectacular mountain that awaited them at the south end of the valley impressed the men so much that they named the mountain Sopris Peak in honor of the expedition's leader. Sopris Peak, with an elevation of 12,953 feet, is now known as Mount Sopris.

GLENWOOD CANYON. Glenwood Springs was not settled until relatively late in Colorado history due to the difficulty of accessing the area. Glenwood Canyon was impassable, so the only route from the east followed the Ute Trail over the Flat Tops north of town. Explorers from the south followed the Roaring Fork River from the Aspen area.

DRAWING OF EARLY GLENWOOD. This drawing by Flora Maxfield depicts the lay of the land in 1883, when the few settlers residing in the area lived in tents. James Landis, the first settler in Glenwood Springs, arrived during the time of Ute occupation. By 1880, he had squatted on the land that would become downtown Glenwood Springs and the Hot Springs Pool.

HARRY LANDIS. Born on January 9, 1883, James Garfield "Harry" Landis was the first child born in Glenwood Springs. His parents, James and Dollie, filed a Certificate of First Born at the Garfield County courthouse as proof. Harry spent his childhood years in Glenwood and died two weeks short of his 18th birthday from a burst appendix. He is buried in the historic Linwood Cemetery.

PIONEER LODGING. This dugout building appears in several photographs of early Glenwood Springs. It may have been constructed by Nims G. Ferguson, Garfield County's first clerk and recorder. Named in honor of Pres. James A. Garfield, Garfield County was carved out of Summit County in February 1883. The mining camp of Carbonate, located on the Flat Top Mountains north of town, was the first county seat.

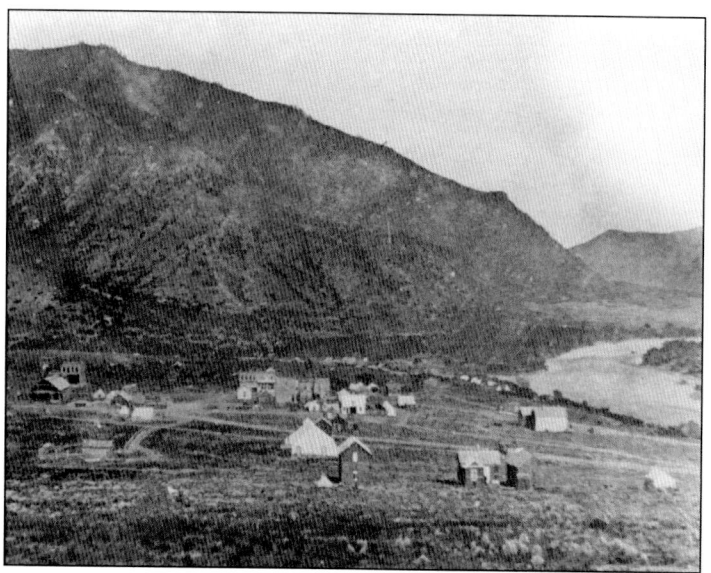

GLENWOOD 1882. When the mining camp of Carbonate was abandoned in the fall of 1883 following an early snowfall, the county records were brought down to Glenwood Springs for safekeeping. Glenwood vied with the town of Meeker in northwest Colorado to be named the new seat of Garfield County. After a contentious election, voters chose Glenwood Springs, which serves as the county seat to this day.

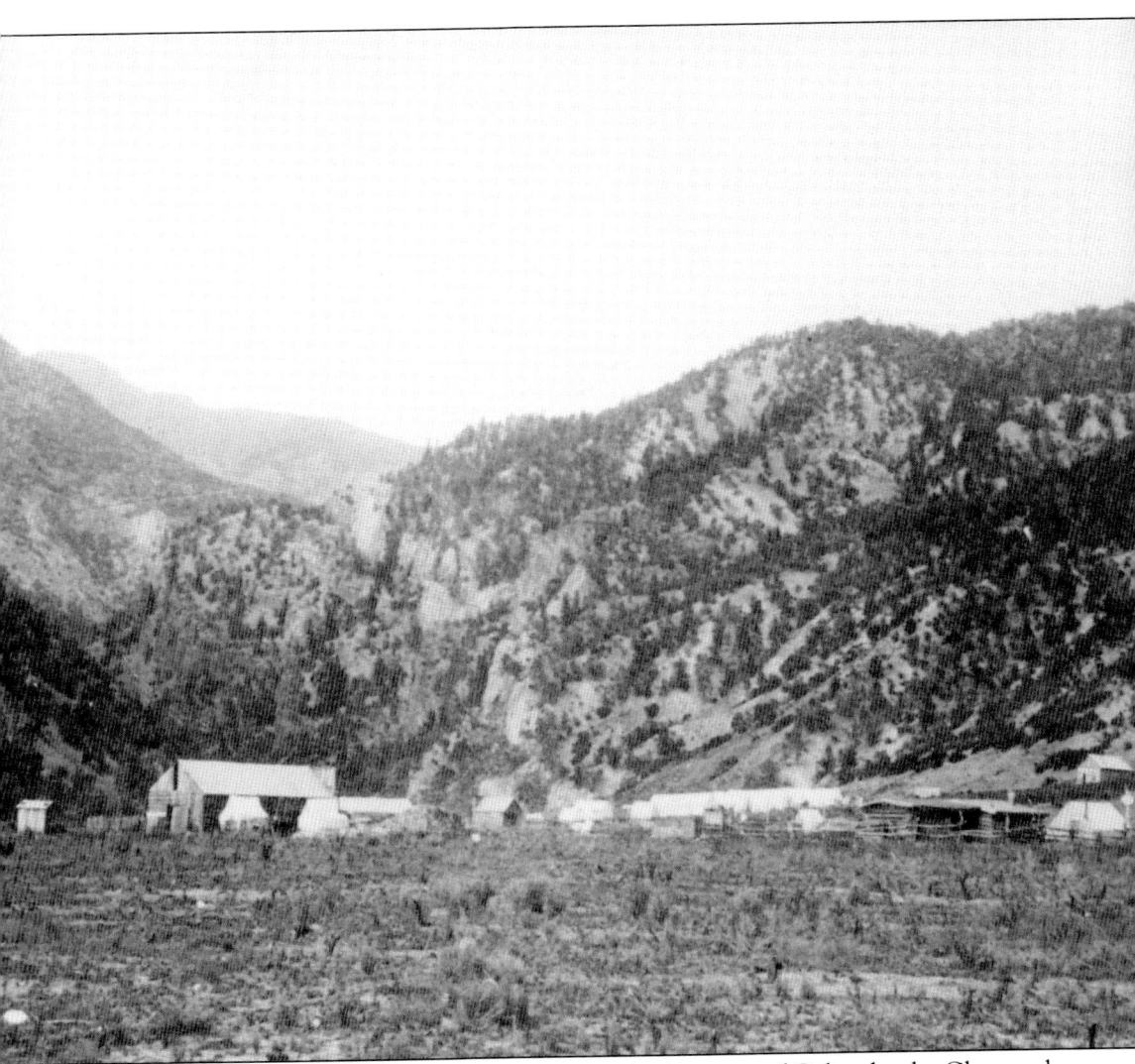

EARLY BUILDINGS. As word of the hot springs reached other areas of Colorado, the Glenwood Springs community saw an influx of new residents. Canvas tents housed new businesses as Bennett's sawmill on the Flat Tops provided the lumber to construct more permanent buildings, which housed dry-goods merchants, bakeries, groceries, hotels, and—of course—saloons. Glenwood's first murder, committed by Elisha Cravens, occurred in Pat Carr's saloon on Riverfront Street in 1885. Cravens was a Confederate Civil War veteran from Kentucky who made his way to Glenwood Springs in 1884 and squatted on land near the Roaring Fork River. He had a penchant for spending time drinking and playing cards in local saloons. One afternoon, he got into an altercation with another patron, George Fuller. They took their dispute into the street, where Fuller bested Cravens in a fight. Cravens left, returned with a gun, and killed Fuller. Cravens was arrested and held that evening under the watchful eye of a deputy, who saved the killer from a lynch mob.

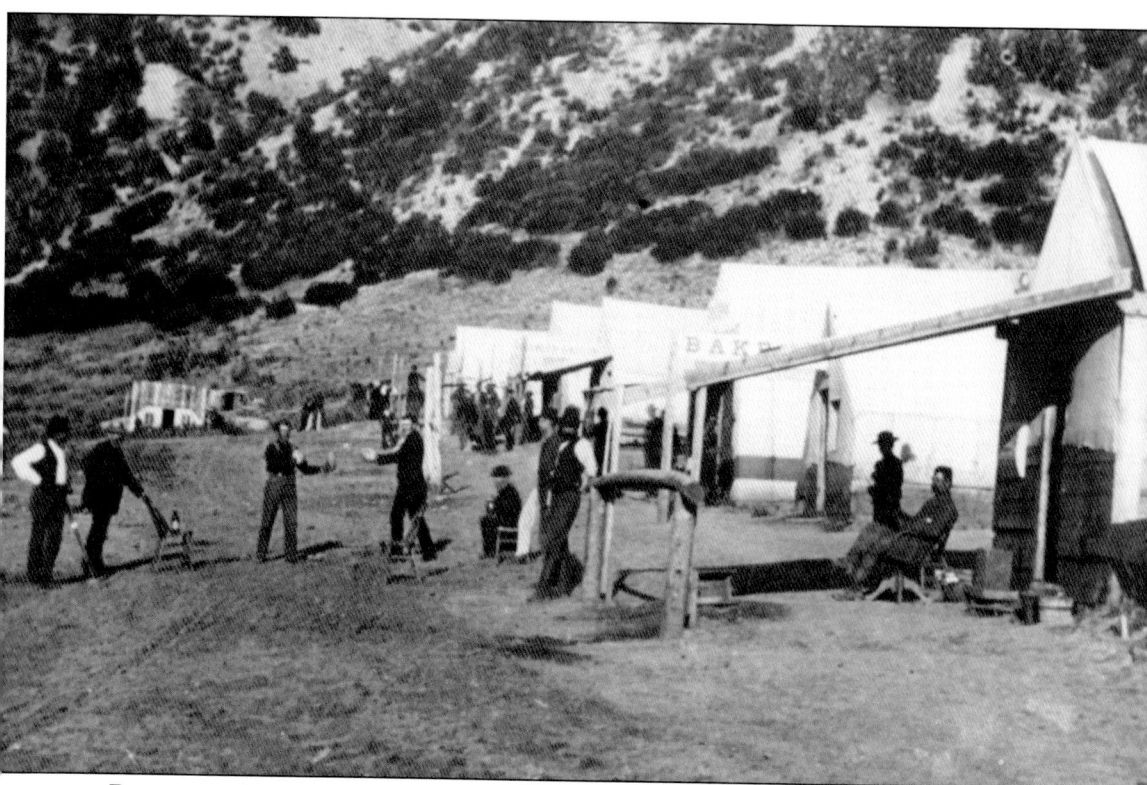

RIVERFRONT STREET. The rough-and-tumble frontier town known as Glenwood Springs was originally named Defiance, and it was platted as such in 1884. However, Defiance was never incorporated as a town, and after an election in which local men voted 55-22 in favor of incorporation, the community was replatted and renamed Glenwood Springs in August 1885. The new plat of Glenwood Springs honored the town's founders with street names such as Cooper (Capt. Isaac Cooper), Blake (Col. John C. Blake) and Bennett (a misspelling of the name of Hiram Bennet, Colorado's first territorial delegate to Congress), as well as the names of important Colorado icons such as Pitkin (Colorado governor Frederick W. Pitkin). Local legend says that Palmer Avenue was named for a well-liked laundress named Lottie Palmer, but it is more likely that the name honored Gen. William J. Palmer, a Civil War Medal of Honor recipient who secured legislation and funding for the Denver & Rio Grande Railroad.

JOSEPH E. SCHRAM. Following incorporation, the town of Glenwood Springs needed a government. In September 1885, a full complement of elected trustees set about the business of writing the first ordinances and governing the new town of Glenwood Springs. The trustees chose Schram, a 35-year-old who owned and operated a successful local grocery store with his cousin Fred, as the first mayor of Glenwood Springs.

STAGE LINES. By 1883, several stage lines, including Carson's Stage and Express Line and Sanderson & Co., ran coaches from Aspen to the hot springs, bringing visitors, new residents, and supplies to the area. Pioneer James Landis ran a stage line between Aspen and the hot springs three times per week. By late 1883, the stagecoaches also carried mail from town to town.

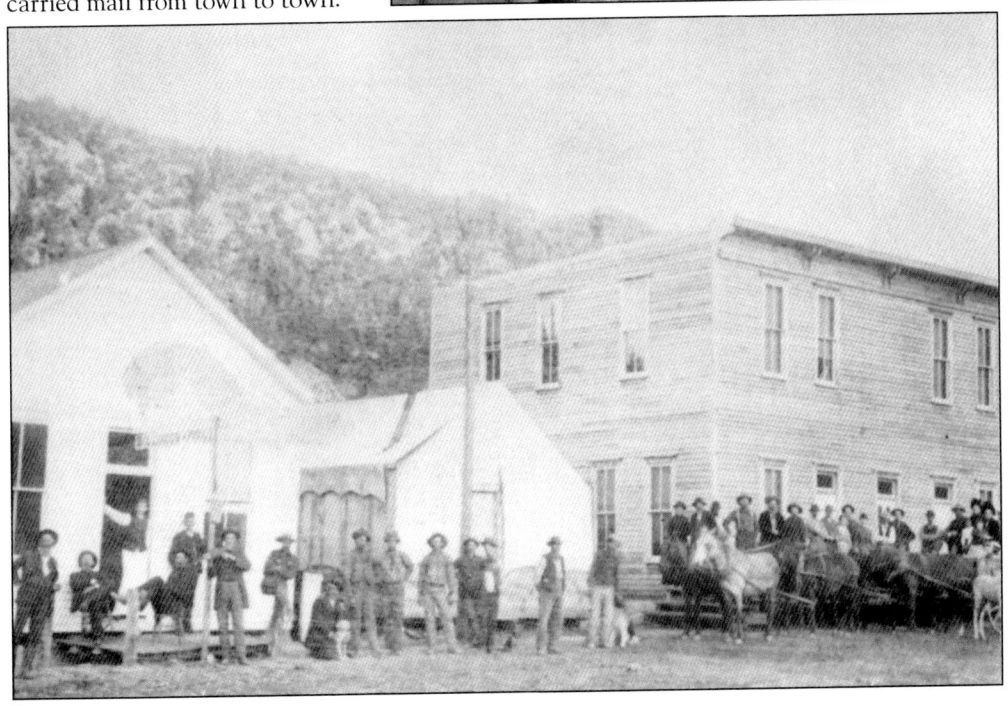

CAPT. ISAAC COOPER. Cooper named Glenwood Springs after his hometown of Glenwood, Iowa, at the insistence of his wife, Sarah, who felt that the name "Defiance" did not convey the sense of welcome needed for a spa resort. Isaac had already established himself in the mining boomtown of Aspen and started a ranch outside of Carbondale at what would later become the site of Cooperton.

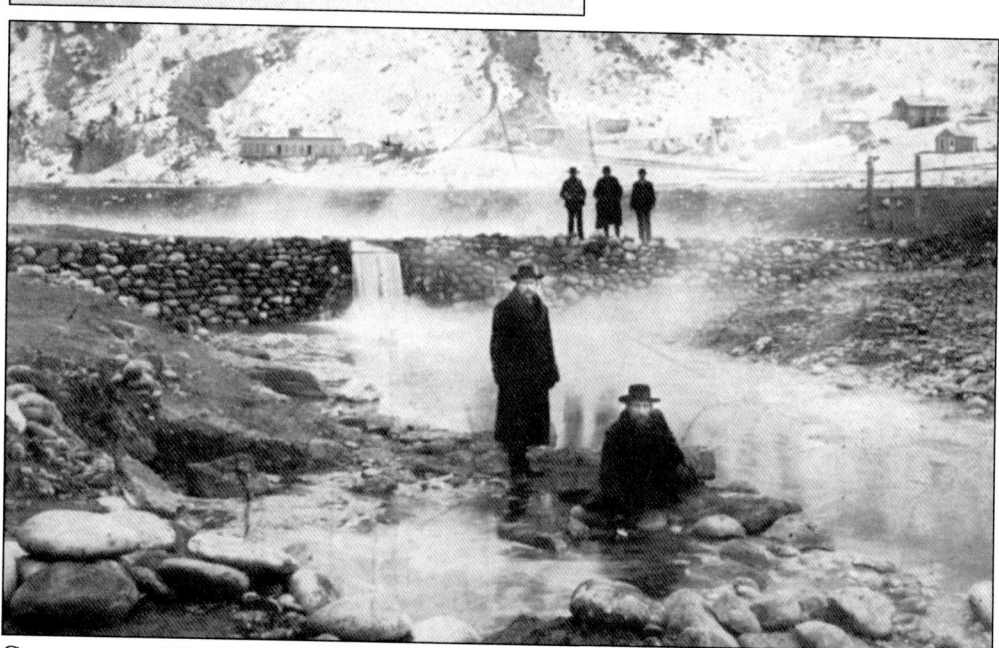

COOPER AT THE HOT SPRINGS. Isaac Cooper had the vision to create a health spa from the natural resources available at the hot springs. He had purchased the property containing the hot springs from homesteader James Landis for $1,500, but although Cooper had the vision, he did not have the financial capital to bring the project to fruition; he eventually sold the property to Walter Devereux for development.

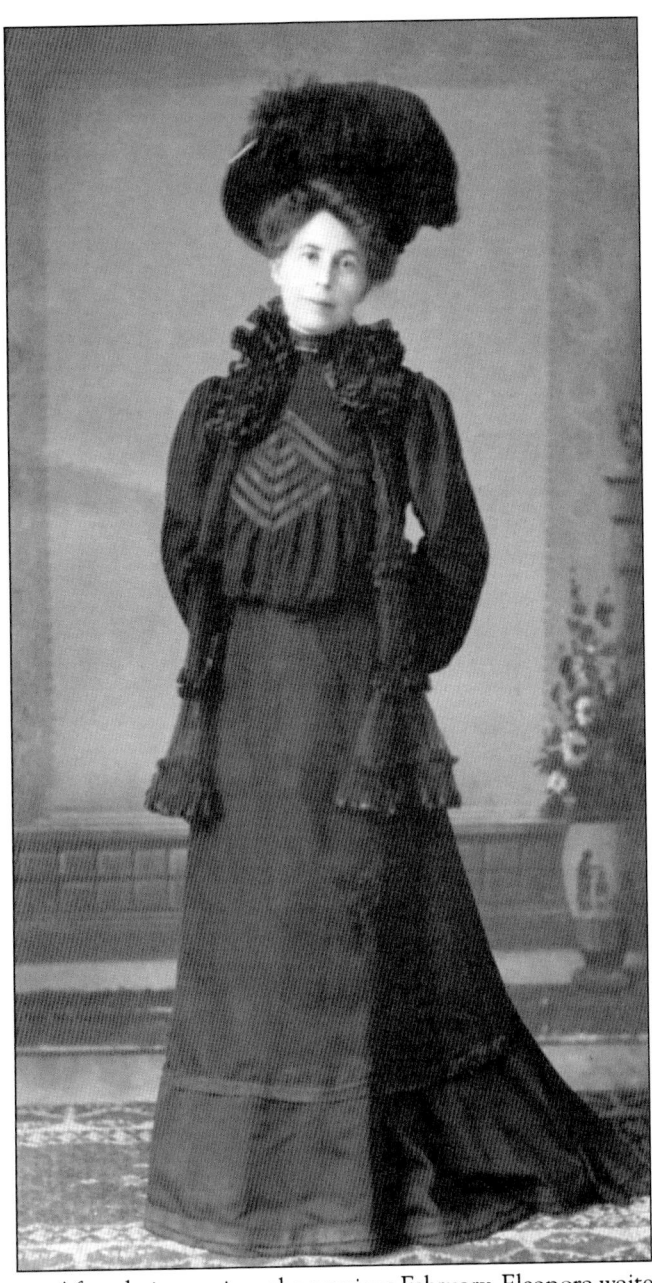

ELEANORA MALABY. After their marriage the previous February, Eleanora waited until May 1885 to leave Ohio and join her new husband, Perry, in the fledgling town of Glenwood Springs. After a six-day train ride to Granite, Colorado, she planned to cross Independence Pass into Aspen by stage, but spring runoff from an immense snowpack the previous winter made the road nearly impassable. Men were allowed to cross on horseback, but women were forced to stay behind. Eleanora convinced her fellow travelers of her ability to handle a horse, and she was allowed to travel with the men. Once they reached the mining town of Independence, the party was able to ride into Aspen, where Perry was waiting for his wife. Upon their arrival, Eleanora's traveling companions would not release her to Perry until he showed them a marriage certificate proving his claim of being her husband. Perry and Eleanora spent the rest of their lives in Glenwood Springs.

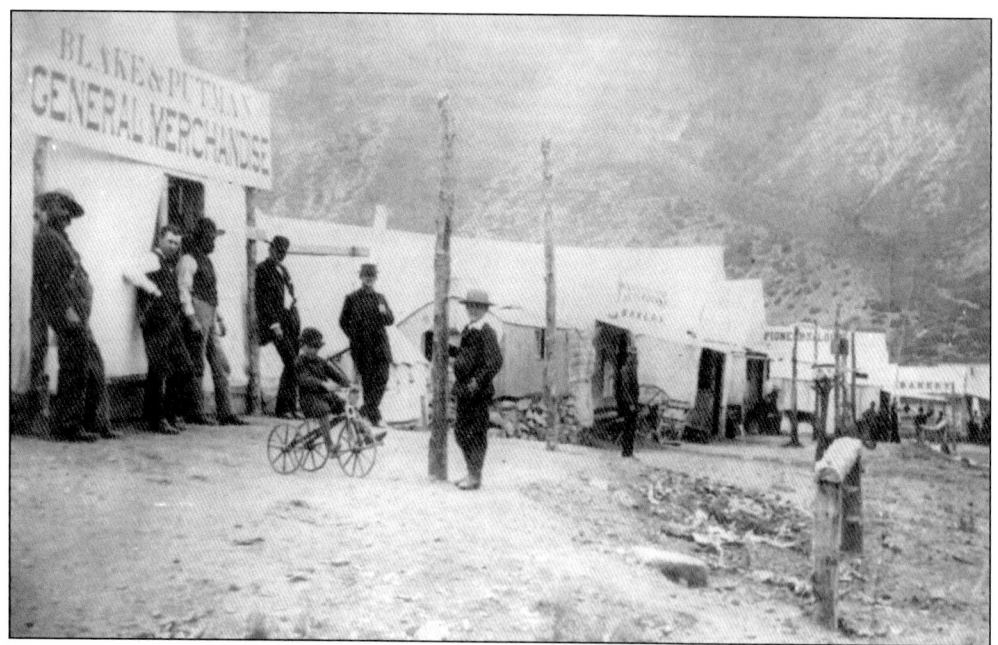

RIVERFRONT BUSINESSES. In the first years of Glenwood Springs, businesses sprouted up along the banks of the Grand (now Colorado) River. One of these establishments was Blake & Putman General Merchandise, owned by town founder John Blake and his partner named Putman. Blake's common-law wife, Gussie, was the town madam, overseeing a brothel filled with "soiled doves." The riverfront area was known as the Sporting District.

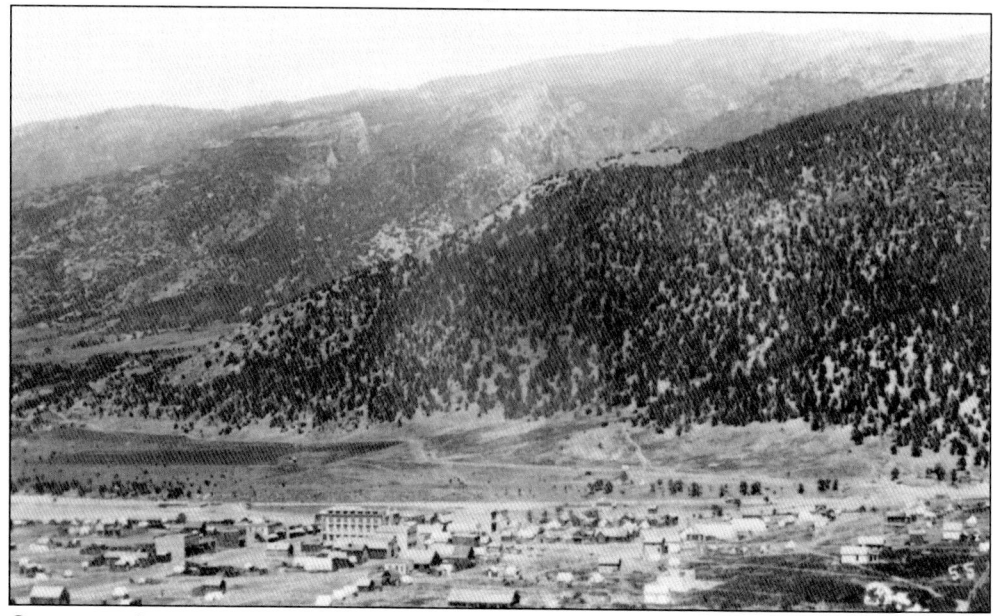

GLENWOOD SPRINGS, C. 1885. When the Barlow family arrived at the hot springs in 1882, they began constructing accommodations to house visitors. Fred and Caroline Barlow built the Hotel Barlow as a tent structure, which locals jokingly referred to as "Venison House" because of its steady menu of deer meat. If anyone needed lodging, $2 would buy them a room and a meal at the Hotel Barlow, which later became the St. James.

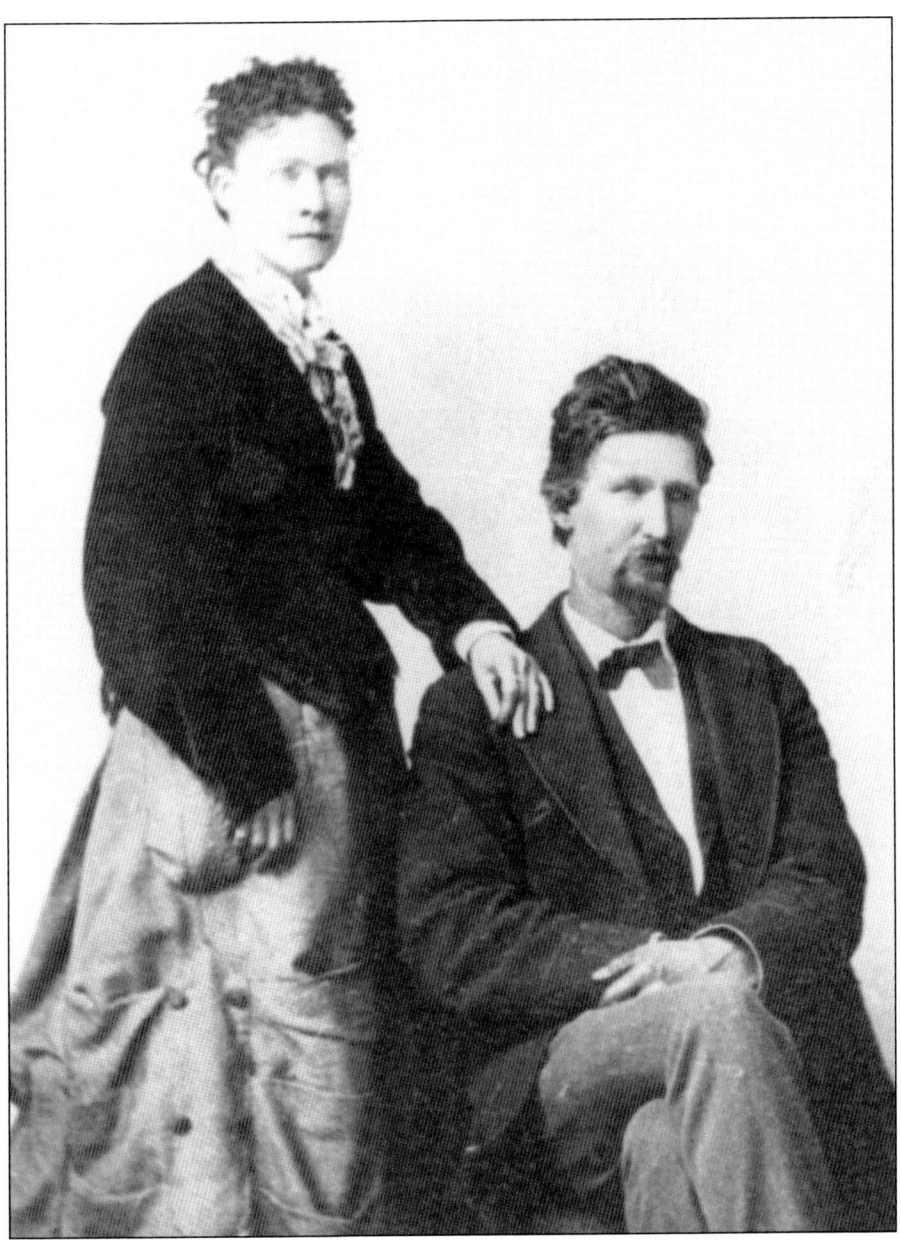

ANNIE AND JASPER WARD. Jasper Ward ran a freighting business with his brothers in several remote mining towns of Colorado. He had been a rabble-rouser in his youth, but with the assistance of a spiritual mentor, Ward found his way and even became a man of the cloth. In the summer of 1883, he moved his wife, Annie, and their daughter Nettie to the area; they were the first settlers in Grand Buttes (now called New Castle). Jasper served as postmaster, town marshal, a preacher, and a saloon owner. In 1887, he volunteered to join troops headed to northwest Colorado for the "Ute Uprising." The government had forced Ute tribe members onto reservation lands in Utah in 1881, but many still traveled throughout western Colorado. Jasper thought he might be able to achieve some kind of peaceful resolution to the uprising, but unfortunately, he was one of two men killed when gunfire erupted. Jasper Ward's body is buried in Glenwood Springs' Linwood Cemetery. Annie, buried by his side, passed away in 1889.

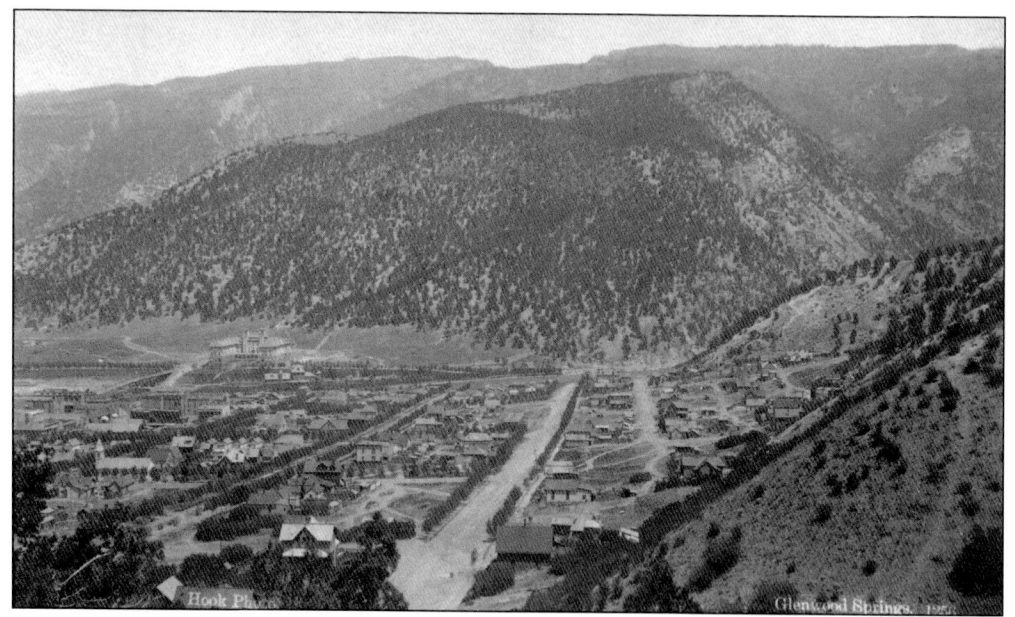

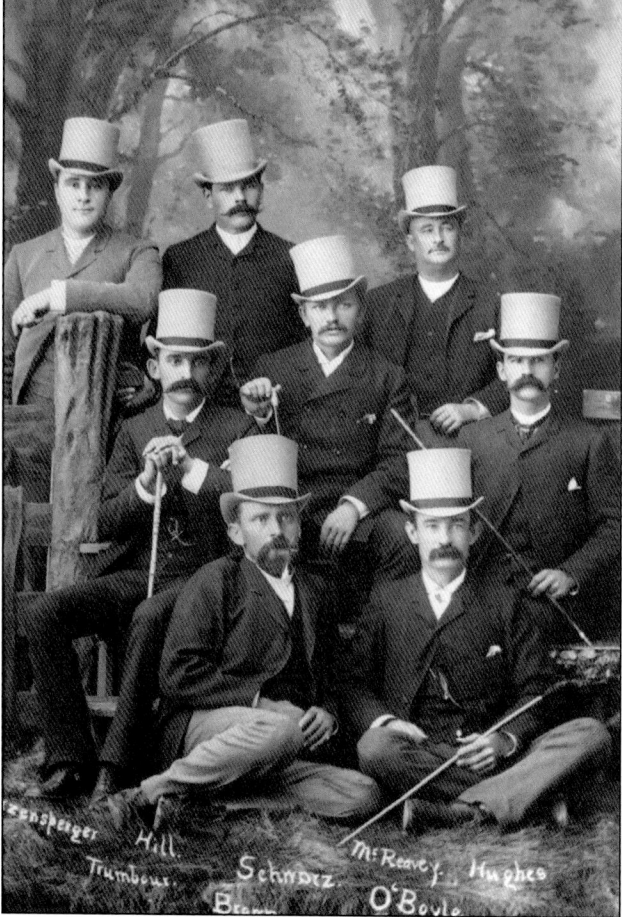

AERIAL VIEW OF THE TOWN. As in many frontier towns of the American West, the first few years in Glenwood Springs were wild and bawdy amid a plethora of saloons, gambling halls, and bordellos. The hot springs lured visionaries—who dreamed of a spa resort to draw in the tourists—and pioneer settlers, who conceived businesses to support the growth of the town.

CITY COUNCIL. In 1888, members of the Glenwood Springs city council had their portrait taken in Denver. The councilmen included Charles Brown, J.J. O'Boyle, W.H. Trumbor, mayor Louis Schwarz, Ed Hughes, Joe Enzensperger, George Hill, and John McReavy. Brown was not available the day the portrait was taken, so a the photographer used a proxy and superimposed a photograph of Brown's face onto the portrait at a later date. The proxy left the studio and was killed in a saloon.

Two

A Health Resort Is Born

A very detailed description of the Grand River hot springs appeared in the May 26, 1883, edition of the *Aspen Weekly Times*. Excerpts from this article describe the hot springs along the Grand River in their natural state, before they were developed several years later.

> We begin with the big springs which supply the lagoon we have mentioned, because the most famous as well as the most copious of all. These break out in a circle . . . right in and along the side of the channel or passage way between the island and the north or right bank of the Grand.
>
> All along bubbles rise occasionally, denoting some flow from springs under water. Hot water trickles in from the north banks of the Grand . . . At present the high water has been mostly shut out from the lagoon and the lower pond is now 250 feet long, 40 feet wide and 4 feet deep. This lower portion of the lagoon is the favorite place for men to bathe. There are no artificial conveniences whatever, but the place is secluded, the bank of the island shutting off the view from the south side, and here, gentlemen at all times of the year undress and plunge into this hot water.
>
> About 8 feet from the cave entrance is Umbrella rock. This is a circular, hollow rock, over which the most of the hot water from the vapor cave pours by various channels into the river. About two feet above the rock extends over and projects beyond Umbrella rock.
>
> In very low water the cave springs cease to flow over Umbrella rock and seek the river through other outlets. Then the path leads along the side of the canon [canyon] in what is now the river. Through one of its openings a person can go under Umbrella rock and combine a vapor bath over springs which bubble up beneath, with a douche bath from various channels which the water finds directly through Umbrella rock. Strange that even nature in her perfect work should provide a leaky umbrella!

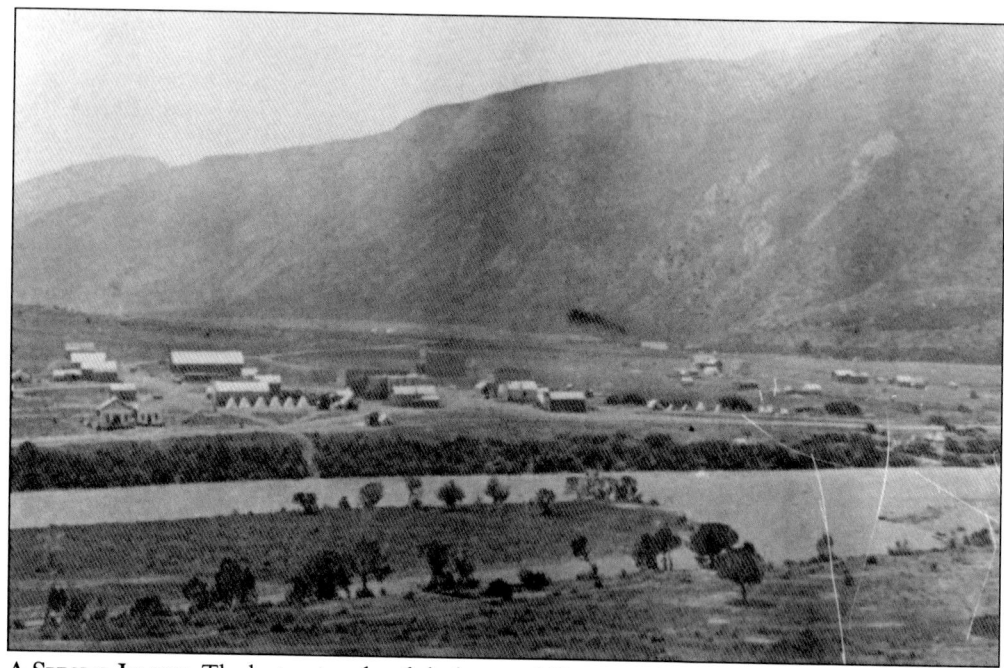

A SPECIAL ISLAND. The hot spring that fed what would become the Hot Springs Pool was originally located on an island in the Grand River. The north channel of the river flowing around the island was filled in with rocks and dirt to create the land where the present-day pool complex is located and connect it to the north bank. Local lawbreakers were given the option of working on the "jailbird rock pile."

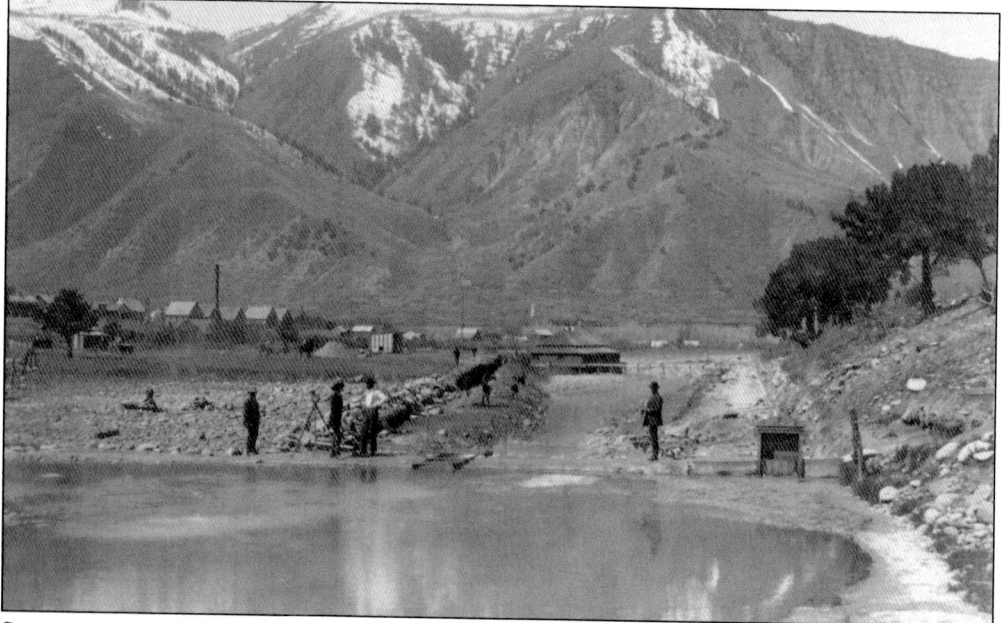

SURVEYING FOR THE NEW POOL. With the big spring in the foreground, surveyors and laborers work to build the Colorado Land and Improvement Company's aqueduct from the main spring to the future location of the pool. The smokestack in the background is from the coal-fired generation plant, which provided electricity to the town as early as 1886.

22

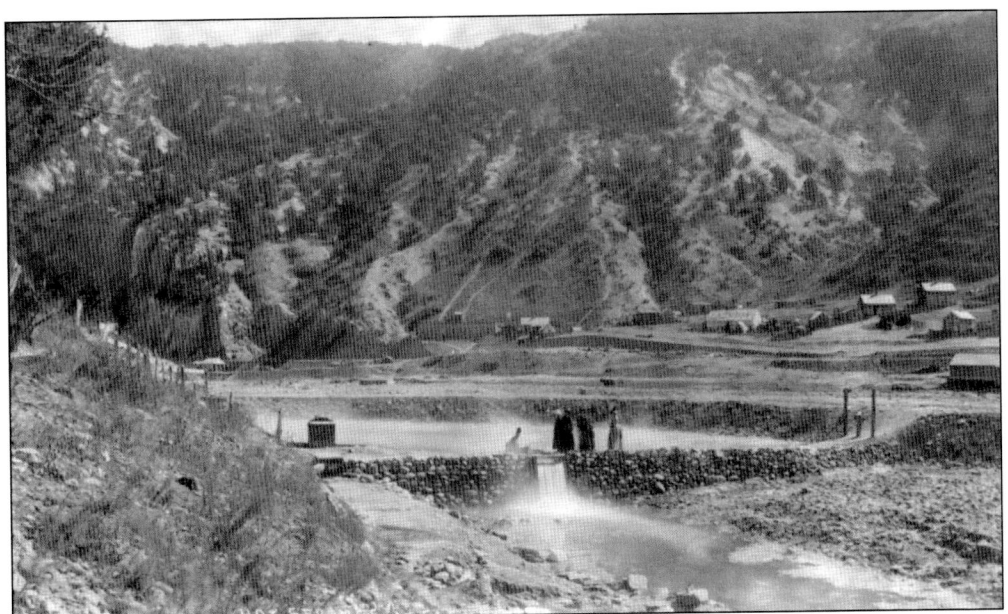

BUILDING THE MINERAL POOL. During the construction of the Hot Springs Pool, this group of women (dressed in long skirts and fancy hats) stood on the stone wall separating the spring from the aqueduct feeding the pool. Vapor Cave No. 1, a building with "laundry" painted on its roof, and several small homes are visible on the south side of the river.

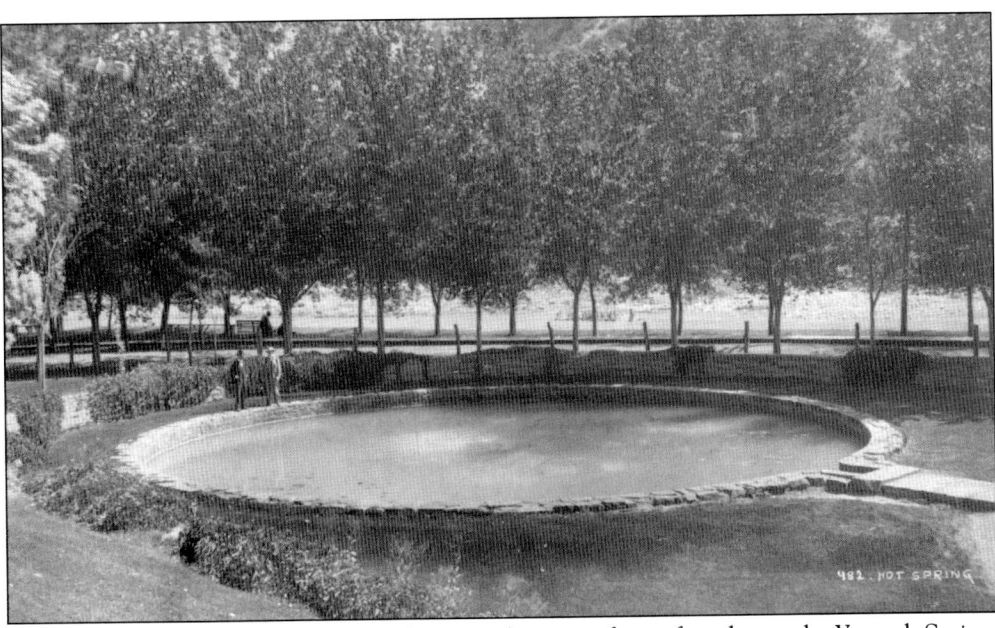

YAMPAH SPRING. The hot water from the natural spring, often referred to as the Yampah Spring, was infused with cool water from the river to create the desired temperature for the Hot Springs Pool. Yampah has generally been regarded as a Ute word meaning "medicine water" or "big medicine," although this has not been confirmed.

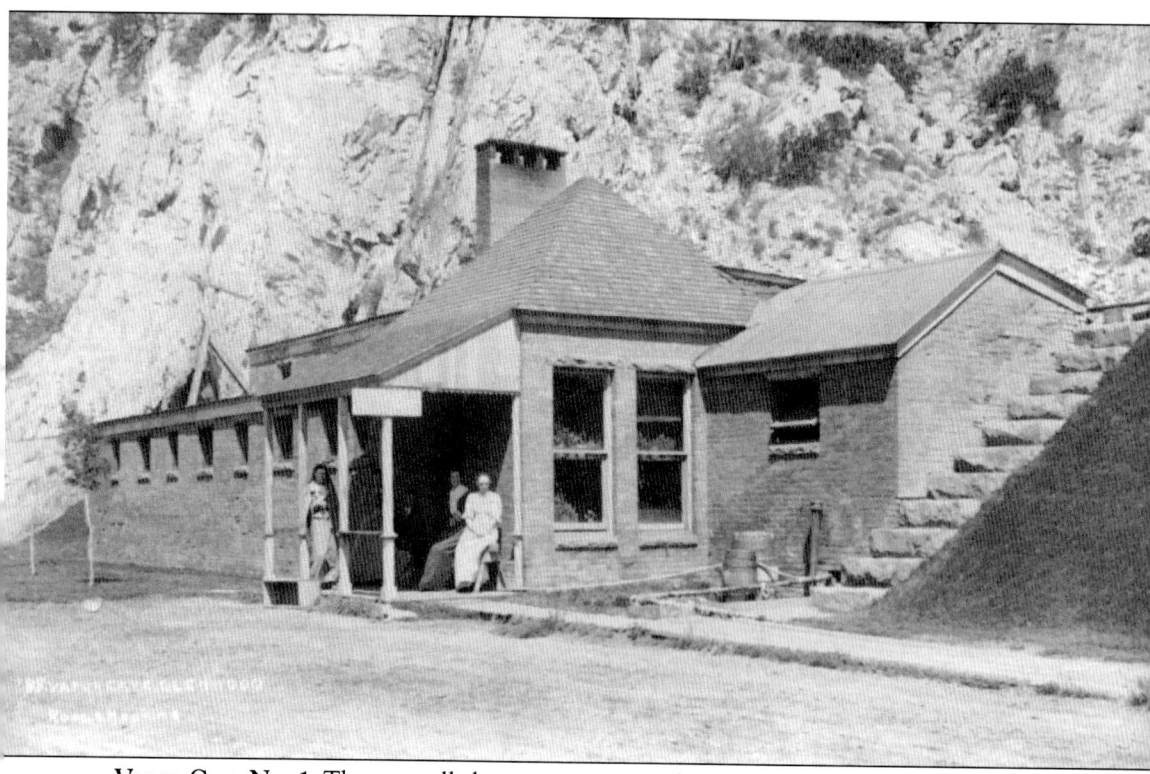

Vapor Cave No. 1. The naturally hot water rising up from underground often filled caves along the Grand River, making them the perfect locations for soaking or sitting and taking in the vapors from the mineral water. In October 1888, the Colorado Land and Improvement Company enhanced one such cave on the south side of the river by building a bathhouse of stone, brick, and lumber. The company had to take a break from constructing the bathhouse at the pool and send workers across the river to work on the vapor cave building. The town council felt that the area needed an improved sidewalk leading from downtown to the vapor cave, so they approved funding for the building of one. The general manager of Colorado Land and Improvement Company, Mason Mather, asked the Denver & Rio Grande Railroad if a boardwalk could be built down the middle of the tracks leading to the vapor cave. Although the Rio Grande representatives felt this boardwalk would be unsafe, they gave Mather permission to build it. The caves were open to men and women at separate times during the day.

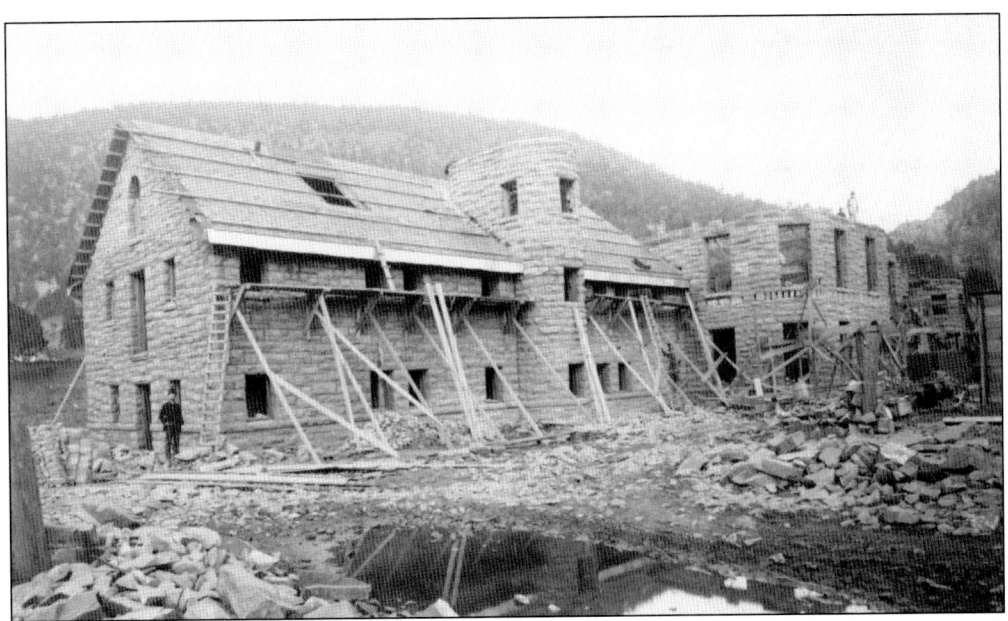

STONE BATHHOUSE. After the Colorado Land and Improvement Company completed the pool, they built a stone bathhouse to be used by those visiting the pool. Theodore Von Rosenberg, a Vienna-born architect and resident of Glenwood Springs, designed the structure, which was built of Peachblow sandstone quarried from an area along the Frying Pan River above Basalt, Colorado, 30 miles to the southeast.

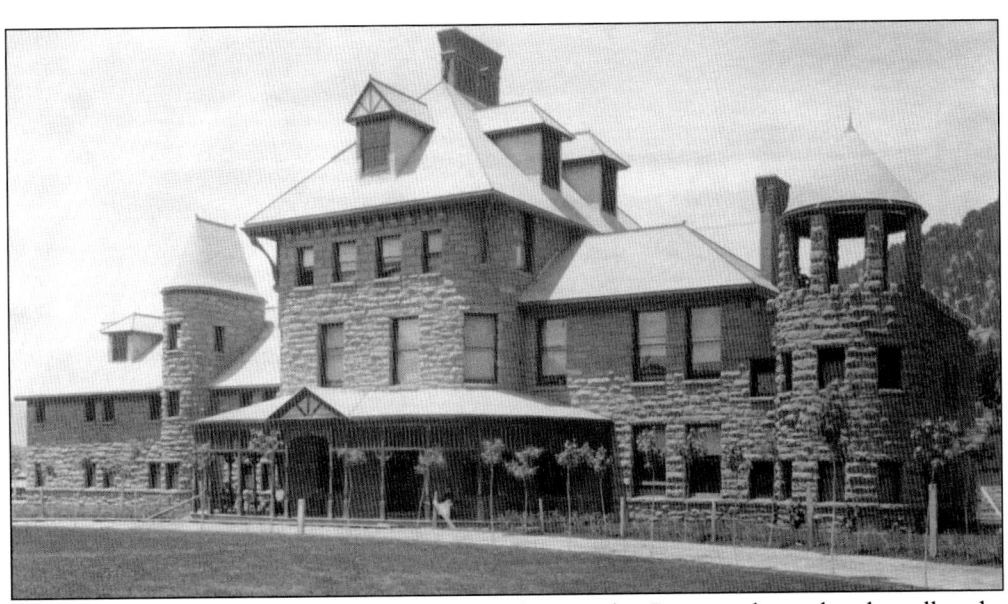

WELCOMING THE WEALTHY. Hot Springs Pool developer Walter Devereux knew that the well-to-do, health-seeking traveler would pay good money to journey to and vacation in Glenwood Springs. Many of these visitors, who were often suffering from nervous exhaustion, would stay for two or three months during the summer to relax and take in the mineral waters.

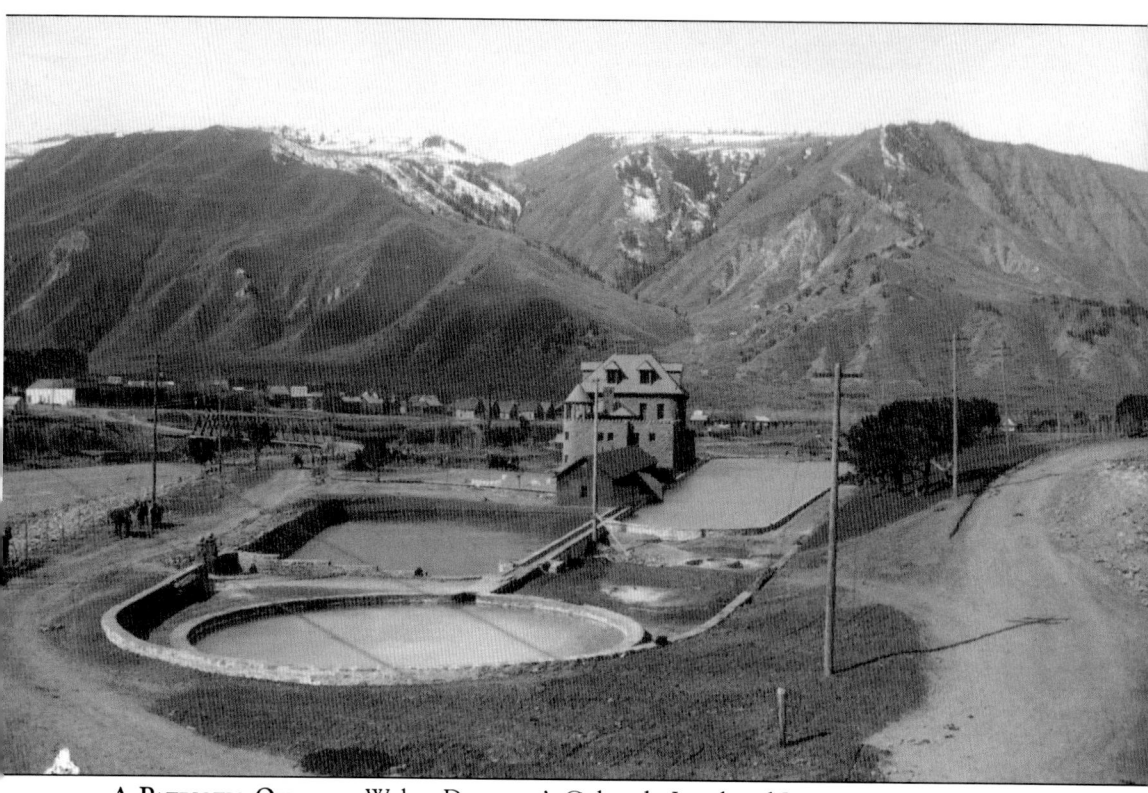

A PATRIOTIC OPENING. Walter Devereux's Colorado Land and Improvement Company began construction of the Hot Springs Pool in February 1888 and celebrated its opening in a dedication ceremony on July 4, 1888. It was a busy day, with gunpowder explosions rocking the town in celebration of the nation's birthday. A parade included the local fire departments—the Glenwood Hook and Ladder Company and the Isaac Cooper Hose Company No. 1. At 10:00 a.m., residents assembled at the pool for the laying of the cornerstone for the new bathhouse. A tin box containing copies of local newspapers was set under the cornerstone. The Colorado Midland Railroad also chose this day to celebrate the opening of the new railroad bridge across the Grand River. During the pool dedication ceremony, attendees were treated to music, speeches, and poetry, and workers set the cornerstone for the stone bathhouse. Afterward, swimmers could take their first dip in the pool.

A Thing of Beauty. By December 1889, the Colorado Land and Improvement Company had completed the stone bathhouse, which included separate gentlemen's and ladies' parlors, private bathing rooms with imported mosaic-tiled walls and floors, dressing rooms, a reading room, a men's smoking room, and a ladies' sitting room in the turreted portion of the building. The lower level contained Roman-style baths with sunken tubs—30 tubs for men and 12 for ladies. The upper floor housed a gambling parlor for men only. Patrons could summon the help with a call bell system, and a resident physician was available to aid guests with health concerns.

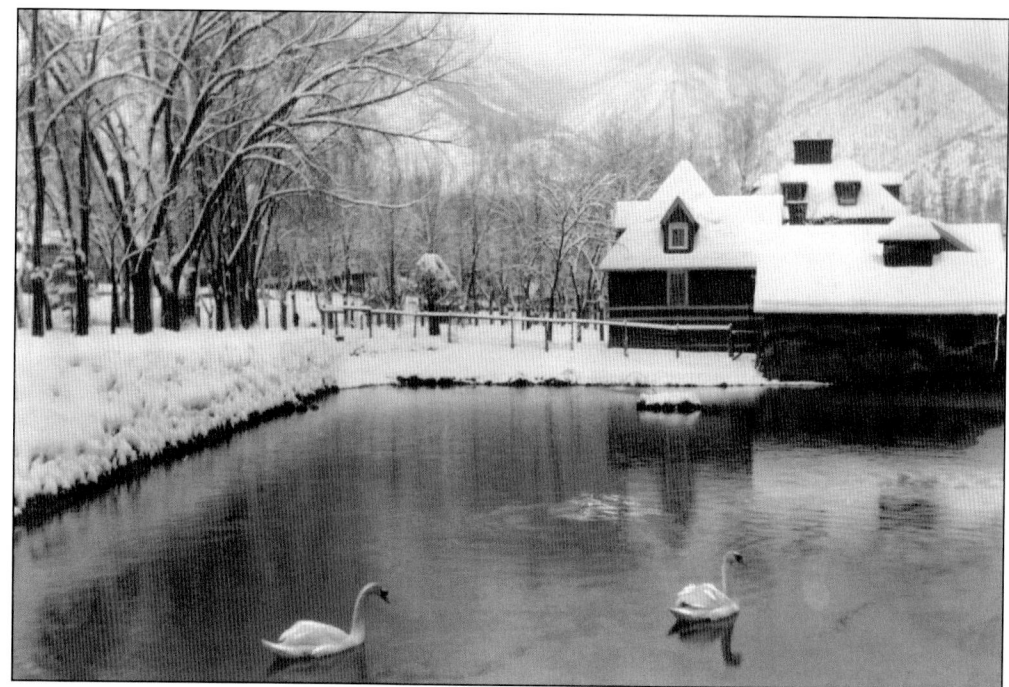

THE SWAN POND. The Swan Pond, located to the east of the wooden bathhouse, was lined with river rock and stocked with its namesake birds. The pond contained a large fountain that was allowed to flow throughout the winter months, eventually freezing into a towering ice structure. Adventurous young men would attempt to climb the frozen fountain. A wooden bathhouse built next to the stone bathhouse offered a place for local citizens to access the pool for an admission fee of 25¢—half the cost of admission to the stone bathhouse. The wooden structure—called the Pool House—separated the locals from the wealthier clientele at the stone bathhouse.

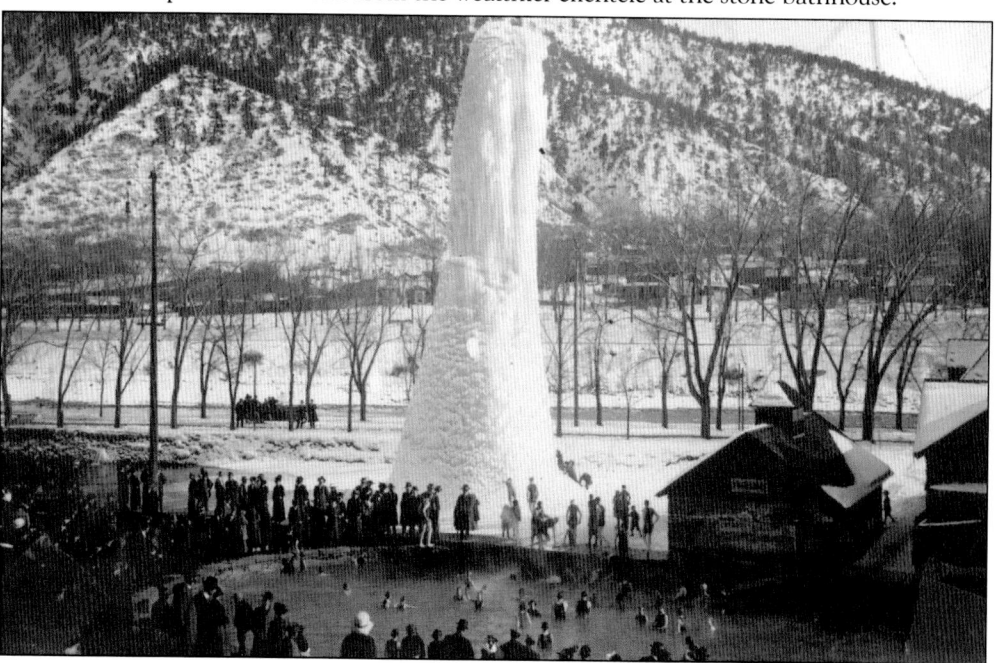

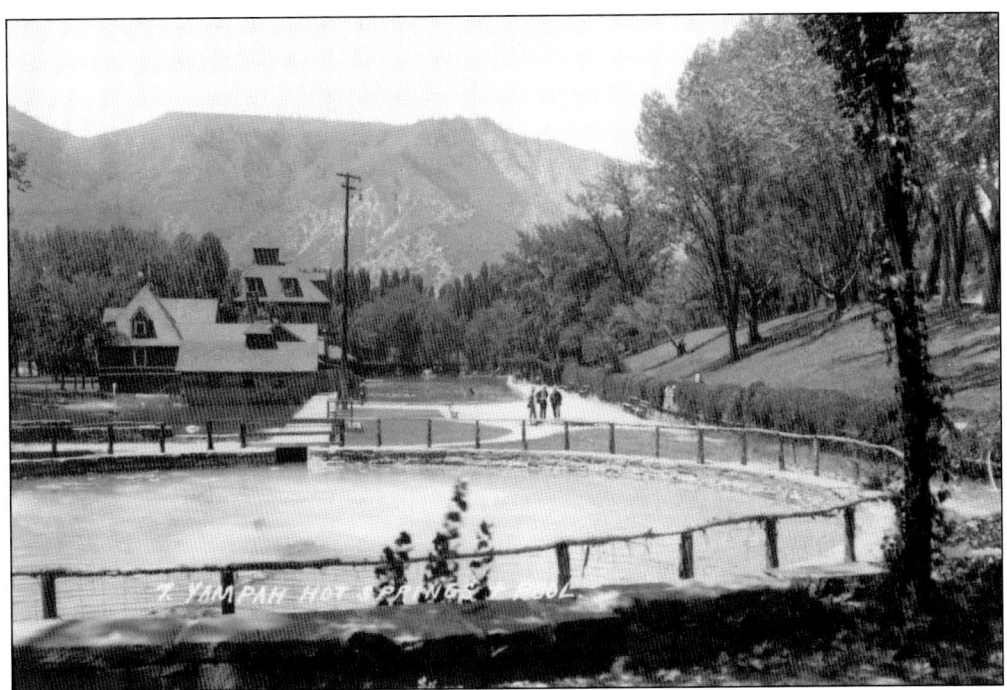

BEFORE THE POOL. In 1881, Swedish immigrant Jonas Lindgren came to Glenwood Springs searching for relief from his rheumatism. Lindgren constructed a wooden bathtub, which he filled with hot mineral water and tempered with pails of cooler water from the river. After a few of these baths, Lindgren began to feel the relief he was searching for. Soon, Lindgren's private spa became a bustling business. Customers seeking to use his tub could do so for 10¢ per bath. Bathers furnished their own towels, and each bather had to carry his own cool water from the river to the tub. Privacy was practically nonexistent. Lindgren's bathhouse was described as having "no overhead protection but the blue sky, and no curtains to protect the bathers from the gaze of the deer and the Ute Indians, except the friendly shrubbery which nature had provided." In 1883, Lindgren purchased a homestead with the profits he had made from selling baths. Both of these images show the Hot Springs Pool.

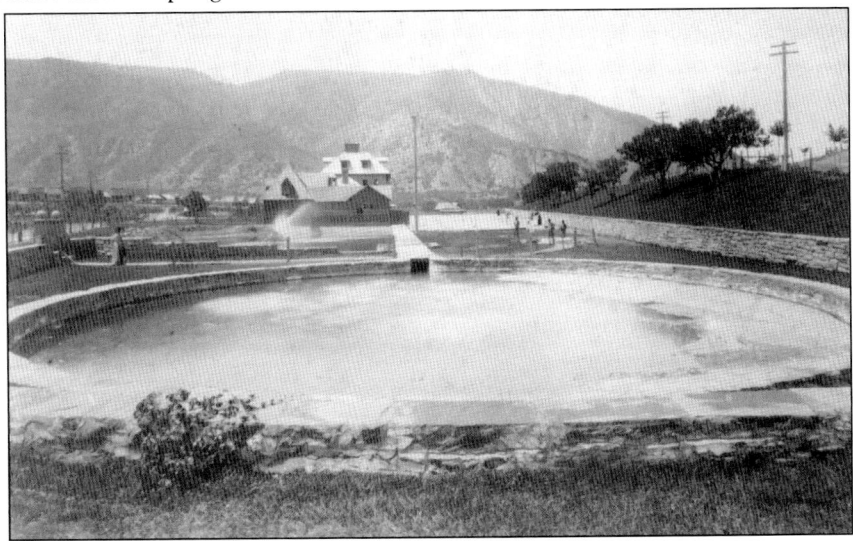

THE DUCK POND. The Duck Pond, a second pond constructed and added to the Hot Springs Pool landscape, was located just west of the pool and extended underneath the state bridge that crossed the Grand River. Along with the Swan Pond, the Duck Pond added ambience to the beautifully terraced and landscaped lawns surrounding the Hot Springs Pool.

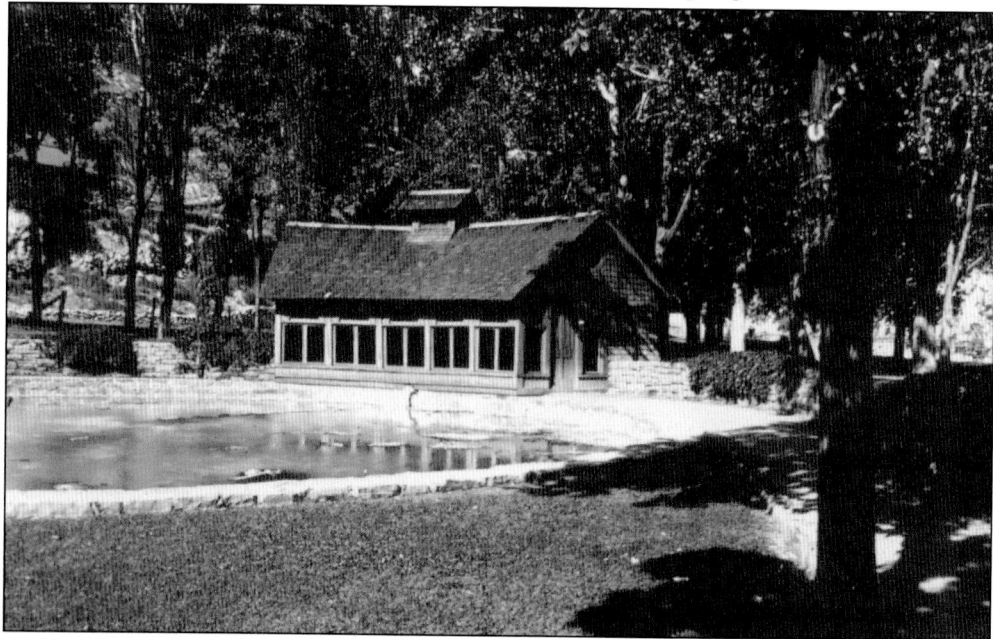

THE INHALATORIUM. This wooden structure with large glass windows was located at the east end of the Hot Springs Pool property. This building—fittingly called the Inhalatorium—was furnished with wicker seating and potted plants and provided a comfortable place to sit and inhale the sulfurous vapors from the mineral waters.

THE COCKTAIL SPRING. Just west of the large Yampah Spring, a smaller enclosure housed a drinking spring. At the drinking spring, or cocktail spring, patrons could drink, gargle, or snuff the mineral water. For a time, young Bartow Duncan was employed to dip cups of water for the patrons. Customers could also purchase bottles of Yampah water. Local bottler Ed S. Hughes had a contract with the Hot Springs Company, owner of the Hot Springs Pool, to bottle the natural mineral water from the spring. The labels on the bottles contained a list of minerals found in the water, including sodium, potassium, magnesium, and lithium. The mineral water, sold by the bottle or the case, claimed to cure ailments such as arthritis, dyspepsia, kidney stones, eczema, and even baldness.

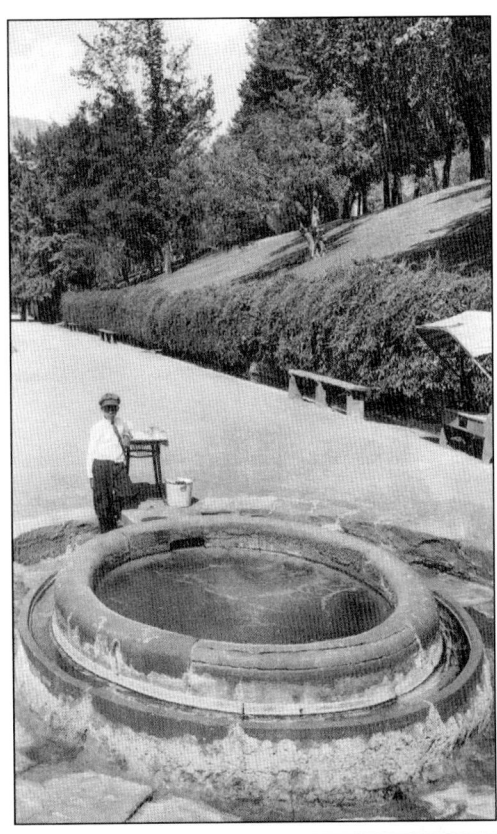

31

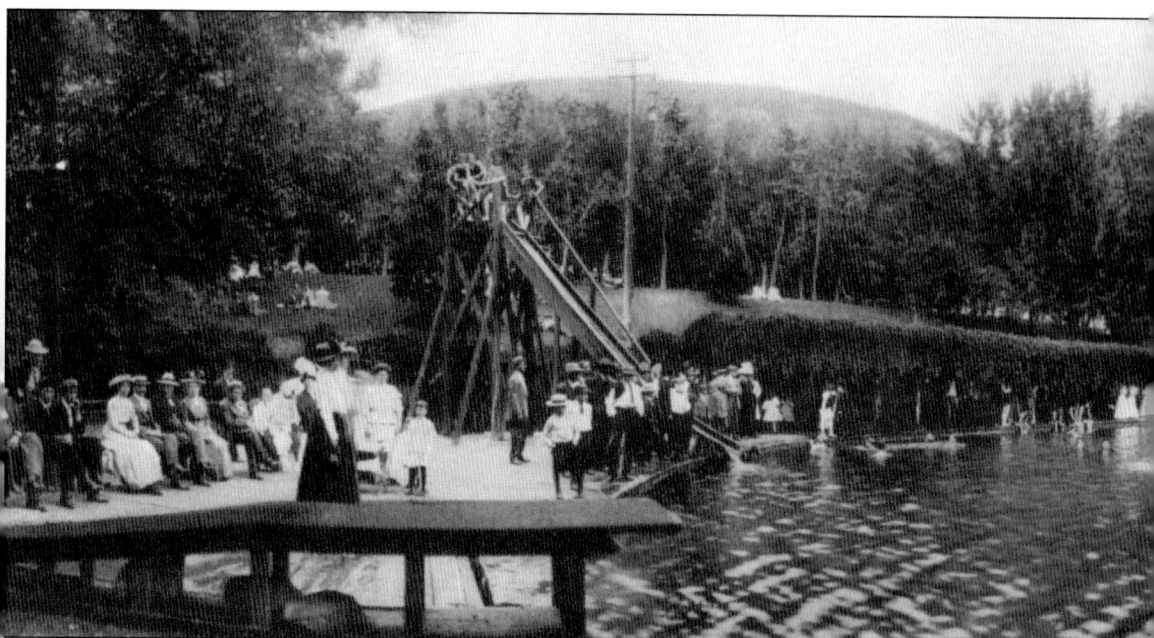

A DESTINATION RESORT. While the health benefits of the mineral water were touted most often in advertising, the pool was also a place to have fun. In 1892, the Hot Springs Company installed a toboggan slide as an option for swimmers. The wooden slide, which was 16 feet tall, was covered in oilcloth and had a stream of cold water running down it to keep it adequately moistened and to

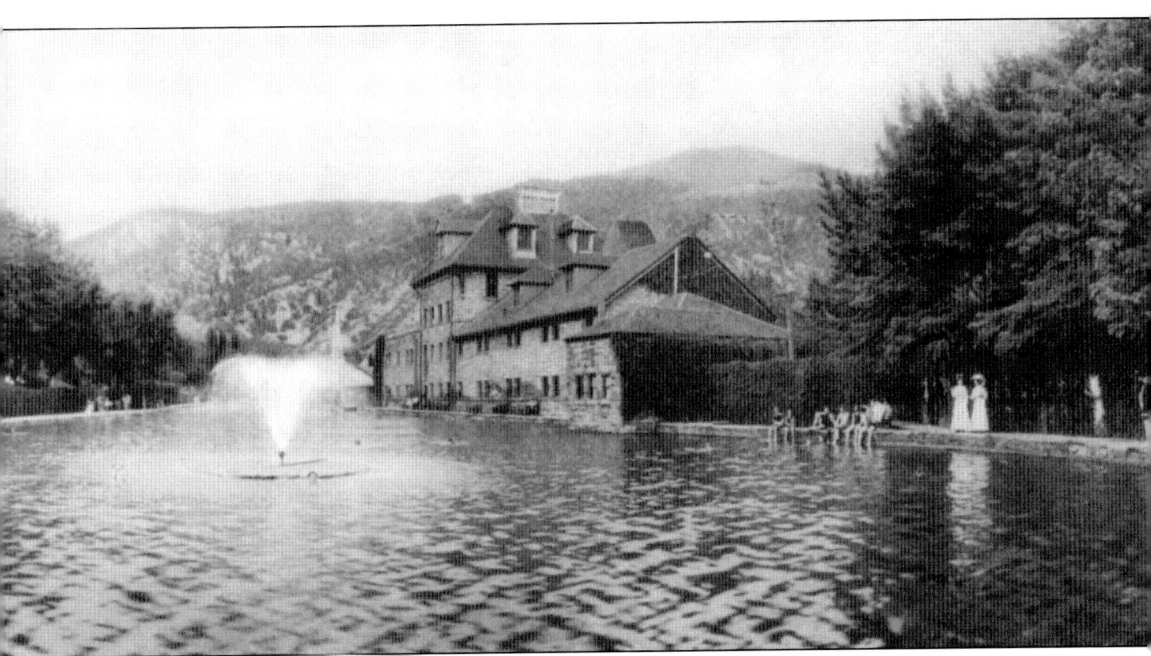

allow bathers to glide into the pool. A freshwater fountain sprayed cold water into the air at the deeper end of the pool and provided a jumping off place for swimmers. Visitors who did not wish to get wet were provided with a shade arbor under which they could sit and watch the bathers. The lawn up the hill from the pool was popular with picnickers.

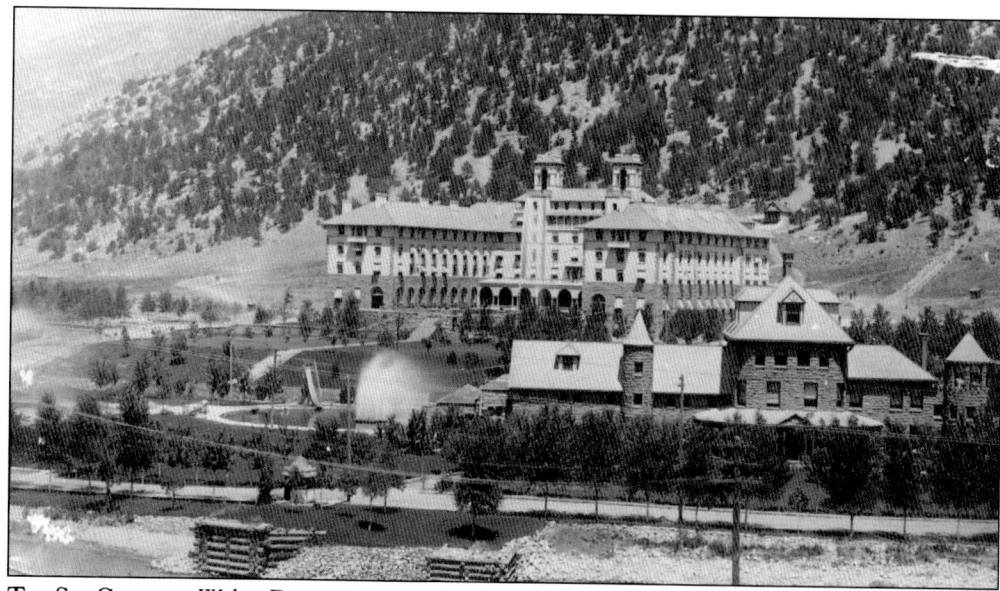

THE SPA COMPLEX. Walter Devereux's vision for a Rocky Mountain spa included the Hotel Colorado, a place where wealthy travelers could stay while enjoying all that the hot springs had to offer. In 1891, Devereux began recruiting investors who believed in his vision for a spa resort; he secured $500,000 in capital—mostly from foreign investors—to build the hotel. This photograph shows the Hotel Colorado and the Hot Springs Pool after their completion.

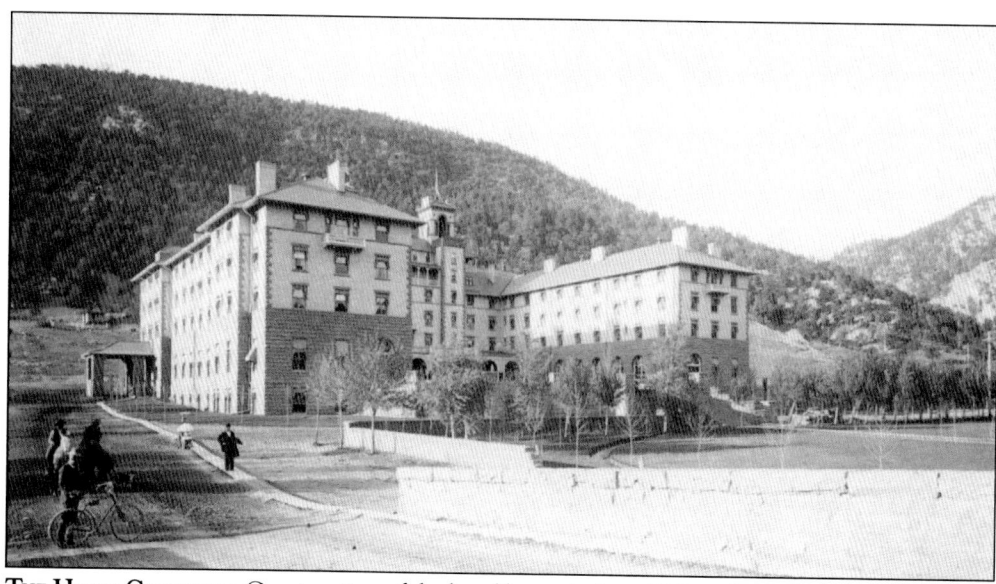

THE HOTEL COLORADO. Construction of the hotel began in June 1892 with an estimated completion date of May 1893. The hotel was constructed of Peachblow sandstone and Roman brick and contained 201 guest rooms, 31 private rooms, 7 public bathrooms, large gathering rooms, a luxurious lobby, and stables in the basement.

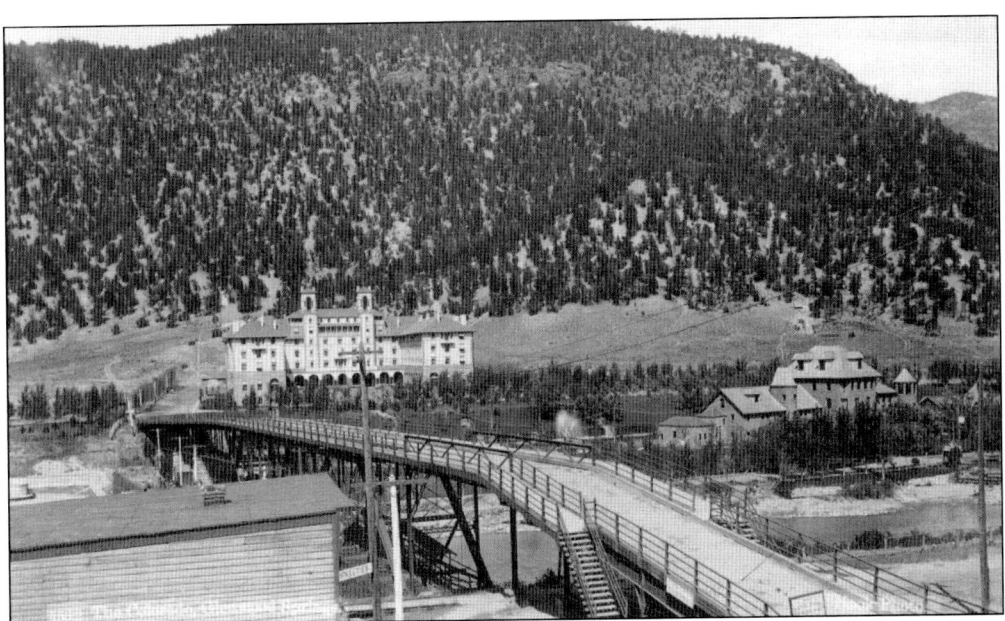

AMENITIES ABOUND. The Hotel Colorado building was 224 feet across and 260 feet from front to back. Devereux built it around three sides of a large 124-square-foot courtyard. A fountain in the courtyard pool sent a plume of water 100 feet into the air. The hotel was heated with water from the hot springs, and the dining room contained a waterfall and pond for fresh trout.

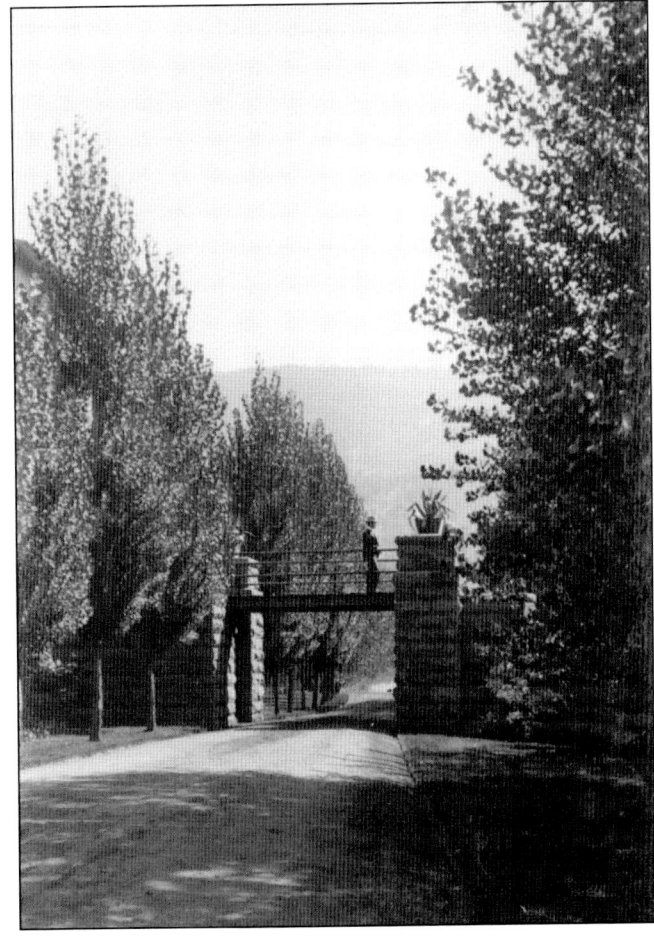

CONNECTING THE PROPERTIES. The Hot Springs Company constructed a footbridge—made of the same Peachblow sandstone used to construct the bathhouse and a portion of the Hotel Colorado—over the road between the two properties to provide safe crossing for patrons traveling between the hotel and the pool. The dirt road in this image eventually became US Highway 6 and 24.

GRAND DAME OF THE ROCKY MOUNTAINS. The Hotel Colorado, designed by the New York architecture firm of Boring, Tilton & Mellon after the style of the Villa Medici in Rome, Italy, held its official grand opening on June 10, 1893, complete with red, white, and blue fireworks. Three hundred couples attended; an orchestra in the ballroom allowed for dancing well into the night; and,

at midnight, employees imported from the best hotels in Boston, Massachusetts, served a sumptuous meal. In the end, the "Grand Dame of the Rocky Mountains" cost $350,000 to build and was the crowning achievement of Walter Devereux's Colorado Land and Improvement Company.

A COVERED ENTRANCE. The west entrance of the Hotel Colorado had a covered portico that allowed guests to park carriages, sleighs, or buggies directly in front of the door. The hotel staff used the open space to the west of this entrance to grow vegetables to serve to guests.

COURTYARD FOUNTAIN. Landscapers kept the grounds of the Hotel Colorado immaculately groomed for the pleasure of the guests. The pool and fountain in the courtyard provided a peaceful place to sit and enjoy the outdoors in the summer months. The Hotel Colorado was closed to guests during the winter.

PROPRIETORS AND MANAGERS. When the Hotel Colorado opened in 1893, Walter Raymond leased the property from its owner, the Colorado Land and Improvement Company. Raymond was a respected manager for Raymond and Whitcomb Excursions, as well as the manager of his namesake hotel, the Raymond, in East Pasadena, California. In 1905, Elmer Lucas (the third man from the left in this photograph) became manager of the Hotel Colorado.

PLAYGROUND OF THE WEALTHY. Visitors to the Hotel Colorado and the rest of the spa complex had little—if any—contact with the residents of Glenwood Springs. The hotel provided guests with lodging, food, and activities that could keep them entertained for months at a time. The hotel also provided private railroad car sidings for guests such as successful packinghouse owner Philip D. Armour and Pres. Theodore Roosevelt.

Hygienic Hades. As the final component in Walter Devereux's health spa vision, his Colorado Land and Improvement Company made improvements to the natural vapor cave east of the pool. The caves had been used by the Ute as a place of healing, and that tradition continued for visitors to Glenwood Springs. Above the caves, the company constructed a brick building that contained dressing rooms and an elevator to take patrons down to the caves. They also installed marble benches in the caves for those taking in the vapors. The main building included a lounging room, which featured electric chandeliers, a fountain, and red and white tile work. Vapor Cave No. 3—referred to as a "hygienic Hades" in *Harper's Weekly*—opened to visitors in 1895. Devereux had developed the perfect health spa and, in the process, secured the future of Glenwood Springs.

WALTER DEVEREUX. Walter Bourchier Devereux, a Princeton graduate, came to Colorado to manage silver mines for Jerome B. Wheeler. As a mining engineer, Devereux patented several improvements and later became Wheeler's partner. Devereux developed a smelter for coal mines fed by the "black gold" from the coal seam that runs from New Castle to Carbondale. Devereux's Grand River Coal and Coke Company also built coal-coking ovens to process the coal.

LAUNDRY TRAINS. The Colorado Midland Railroad serviced a weekly run from Aspen to Glenwood Springs on Saturdays that brought miners and their weekly paychecks for a day of fun at the pool, saloons, and brothels in Glenwood Springs. Eventually, the miners complained about not having enough time, and the Midland changed the train schedule so they could return on Sunday.

A CURE-ALL. Whether the claims were true or just propaganda, testimonials to the curative powers of the hot springs were printed in local newspapers such as the *Glenwood Echo* and the *Ute Chief*. One example comes from 1887, when Johnny Eitel, of the Exchange Saloon, claimed that his feet and ankles were so painful that he could not walk; after two days of soaking in the mineral waters, he was able to walk without the use of his cane.

Three

BUILDING A TOWN

A special edition of the *Avalanche Echo* newspaper published in 1893 endeavored to describe the state of affairs of Glenwood Springs and its surrounding communities. The newspaper's front page is full of photographs, drawings, and articles about the successes achieved over the previous 10 years.

> Thus Glenwood of these days—thus the germ from which has sprung the Glenwood of today—the great health resort toward which wanders the invalid of the east, north and south, the Mecca of those poor in health, who find her the remedy for all their troubles – the natural 'antidote for their banes.' So rapidly spread the fame of the waters and so fast was the influx of settlers that the railroads, ever looking out for new territory to conquer, began to head this way and ere long the Rio Grande, closely followed by the Colorado Midland had Glenwood down on their maps as one of the their stations. From that day to this the progress of the city toward metropolitan proportions has been rapid. The springs which were readily recognized as the prime factor that would enrich the city, were walled in, a handsome pool was built, a magnificent bathhouse, drainage and various other improvements followed. The merchants built stores, the private citizens built homes, the hotel sprang up to cater to visitors while the newspaper put in its appearance to inform those here of what the outside world was doing, and the latter of what was being accomplished in Glenwood. Water works, the electric light system, and the many other component parts that go to make up the modern city appeared in quick succession, and Glenwood Springs from the 'medicine waters' . . . grew to the fair, live and substantial city, as we know her in this year of our Lord.

DOWNTOWN GLENWOOD SPRINGS, C. 1900. The Defiance Town and Land Company platted the new townsite of Glenwood Springs and sold lots to eager buyers. The company included principals Isaac Cooper (president), William Gelder (vice president), D.C. Dodge (secretary-treasurer), Hiram P. Bennet, and John C. Blake. In 1883, S.E. Pascoe bought the first lot for $250. The company withheld the rights to the hot mineral waters on each deed of sale, preventing anyone from digging or boring into the ground to utilize the hot mineral water. They also offered free lots to anyone willing to build a brick home or business during 1884. Henry Kamm took advantage of the offer and built a brick business on the corner of Eighth Street and Grand Avenue to house his grocery and mercantile, which had living quarters above the store.

GARFIELD COUNTY. In 1883, the Colorado state government carved Garfield County out of a portion of Summit County and set up the first county seat in Carbonate, a mining camp on the Flat Tops. The courthouse was nothing but a canvas tent, and the county commissioners were concerned about the safety of the records. As a harsh winter descended in October of that year, the commissioners moved the records to Glenwood Springs. Clerk and recorder Nims Ferguson used a log dugout (pictured above) at the east end of town as the new temporary Garfield County courthouse. In November, voters had to decide between Glenwood Springs and Meeker as the permanent county seat, and Glenwood Springs won. The Garfield County courthouse was temporarily located in a building, leased by John C. Blake, that was formerly a brothel managed by Blake's common-law wife, Gussie.

Temporary Courthouse. This brick-and-mortar courthouse building, constructed in 1887, housed the county jail in addition to county administration offices. It was located on the southeast corner of Eighth Street and Pitkin Avenue, and although it was supposed to be a temporary courthouse building, it remained in use for 42 years.

Clerk and Recorder's Office, c. 1899. This photograph shows the interior of the Garfield County Clerk and Recorder's office. William Cardnell is seated at the desk; his daughter Emily Cardnell is standing at right. The other two men are unidentified. Prior to serving as clerk and recorder, Cardnell managed the *Glenwood Echo*, *Daily Republican*, and *People's Herald* newspapers.

MUNICIPAL WATER SYSTEM. In 1887, residents of Glenwood Springs started a movement to create a water system to pipe fresh water to each home and business in town. Bids went out, and the Glenwood Springs City Council chose Crystal Water System and their plan to take water directly from the Roaring Fork River. Once the council discovered how polluted the Roaring Fork was (due to mining operations upstream), they threw out the bid. At the end of the new bidding process, the council awarded the contract to town founder Isaac Cooper. After Cooper's death in December 1887, Walter Devereux's Colorado Land and Improvement Company took over the contract. The system fed water from No Name Creek into town through a wooden flume along the wall of Glenwood Canyon (pictured in these images) and pipes across the Colorado River.

GLENWOOD LIGHT AND WATER COMPANY. In 1887, when Walter Devereux's Colorado Land and Improvement Company took over Isaac Cooper's contract to furnish the town with a water system, Devereux took the opportunity to form the Glenwood Light and Water Company. In addition to piping fresh water to the residents and businesses of the town, he built a hydroelectric generation plant (the exterior is pictured above, and the interior is pictured below) that utilized the water he brought into town. The plant was located just east of the hot springs, between the pool and the vapor caves. The new company strung electric wires throughout the town, providing power to businesses and residents. In 1908, a competitor—Mutual Light and Water Company—challenged the Glenwood Light and Water Company's prices. Mutual strung wires alongside those installed by Glenwood, and Mutual offered competitive pricing until it went bankrupt in 1917.

FIRE PROTECTION. The Glenwood Hook and Ladder Company, the first volunteer fire department in town, formed in early 1887. Since they had no funding, they disbanded and formed the Isaac Cooper Hose Company No. 1, which was funded by Isaac Cooper. In this 1910 image, Glenwood firemen pose on a rare foggy day in downtown Glenwood Springs with their fire hose cart.

KEEPING UP WITH THE TIMES. In 1917, members of the Glenwood Springs volunteer fire department petitioned city council to purchase a fire truck to replace the hose carts they had been using for the past 30 years. The city council approved the $3,465 expenditure, and the fire department purchased this Brockway fire truck with American LaFrance equipment.

FIRE DEPARTMENT PROMOTION. On a cold winter day in 1922, the hearty members of the Glenwood Springs Fire Department posed for this photograph with their fire truck on the grounds of the Hot Springs Pool. The photograph was included in the January 1923 edition of *Fire and Water Engineering* magazine to promote the fire department and Glenwood Springs.

BLAKE STREET SCHOOL. Prior to the opening of Blake Street School in 1887, local children were educated in a tent on the riverbank by Lucy Peebles. Built at a cost of $26,000 and constructed of light-colored brick, this school housed first through twelfth grades and had electric lights and a steam heating system.

A SIGN OF PERMANENCE. The Blake Street School became a symbol of stability for locals and their children. A solid place of learning was a source of pride for the community, and the local *Ute Chief* newspaper issued weekly reports on school activities and the progress of students. This 1895 photograph shows Rose Campbell's second-grade class.

CHRISTMAS CELEBRATION, 1912. Students at the Blake Street School pose for a photograph inside a classroom decorated for the Christmas holiday with a tree and tinsel, crepe paper, evergreen branches, and stockings. The two-story school had enough classroom space for 200 students and employed five teachers when it opened in September 1887.

A NEW HIGH SCHOOL. By the early 1900s, the school population had grown to a point of overcrowding at the Blake Street School. It was decided to build a separate structure to educate high school students from all 14 school districts in Garfield County. In May 1910, the Garfield County Union High School District was formed.

GARFIELD COUNTY HIGH SCHOOL. In 1913, voters passed a bond issue to fund a new school building. The Garfield County Union High School District purchased seven acres, which had been the local horse-racing track, from Charles Darrow for $500 per acre. Local architect Theodore Von Rosenberg worked with Denver architects Willison and Follis to design the 26-room building, which opened to 117 students in 1915.

GRADUATING CLASS OF 1906. The Glenwood Springs High School class of 1906 included, from left to right, (first row) Blanch Louise Miller, Ann Eliza Needham, Margaret Una Malaby (Howard), May Dorgan McReavy (Schutte), and Mary Lavina Sharpe; (second row) Estella Edinger, Lizzie Logan, Clara Tomasson, Jessie Viola Harkins, and Dolly Esther Duncan.

GRADUATING CLASS OF 1905. Glenwood Springs High School class of 1905 from the Blake Street School included, from left to right, ladies Mary Drach, Viola Hill, and Dora Hymes, as well as gentlemen Jim Ford, Walter Parkison, Bert Cross, Carleton Hubbard Sr., and Ellis Crissman.

FIRST PRESBYTERIAN. Dedicated on October 7, 1887, the First Presbyterian Church is the oldest existing church in Glenwood Springs. The building has changed over the years and has hosted several prominent worshippers, including Pres. Benjamin Harrison in 1891 and Pres. Theodore Roosevelt in 1905. Mary Devereux, whose husband, Walter, developed the Hot Springs Pool, was a devoted member of the congregation and a financial backer of the church's construction.

METHODIST CHURCH. The Presbyterians, the Catholics, and the Methodists initially held services in Hyde Hall at different times on Sunday mornings until each congregation grew to a point that they were able to erect their own church buildings. In April 1893, the Methodists opened their first church at 822 Blake Avenue under the guidance of Rev. Henry M. Law.

St. Stephen's Catholic Church. St. Stephen's began thanks to the efforts of Fr. Edward Downey, the founder of St. Mary's Catholic Church in Aspen. The modest frame building, located at Tenth Street and Blake Avenue, was divided into two rooms and included pews, carpet, lighting, heat, and an organ. It was dedicated in November 1886.

Federal Building. Post offices moved around Glenwood Springs quite frequently in the early days. Caroline Barlow received mail for residents at Glenwood's first post office—a tent. Post office locations moved depending upon who was postmaster at the time. In 1919, this federal building at 902 Grand Avenue housed the mail distribution offices.

POST OFFICE INTERIOR. In 1910, the post office was located at 805 Grand Avenue and headed by postmaster Ollie Thorson, who had completed construction of the building in 1909. That same year, Thorson received approval to provide home mail delivery. Prior to that, residents had to come to the post office to pick up their mail. Ernie Rowe and Maggie Malaby are pictured here behind the counter.

MAIL DELIVERY EVOLVES. With the arrival of automobiles, postmen were able to move larger quantities of mail more quickly. Large bags of mail, such as those shown here, could be driven to the railroad depot and loaded onto trains to travel to distant locations. Mailman Ernie Rowe (right) and an unidentified post office employee are shown here behind the post office at 902 Grand Avenue.

MAKING WORK EASIER. When home mail delivery began in 1909, postmasters were required to hire people to serve as mailmen. Glenwood Springs resident Ernie Rowe worked as a mailman for many years. He is shown here with a homemade mail delivery sled he used to deliver packages.

FIRST NATIONAL BANK. The private bank George Arthur Rice and Co. received competition when five prominent businessmen formed the First National Bank in 1886. James Hagerman, Jerome Wheeler, D.R.C. Brown, Walter Devereux, and George Hewitt invested a total of $50,000 to start the bank and constructed a building at 802 Grand Avenue. The First National Bank in Glenwood Springs opened for business on June 1, 1887.

A Lasting Legacy. A successful banking operation requires an excellent cashier, and First National Bank found one in John H. Fesler, who began working at the bank when it opened in 1887. He had ample banking experience, and it came to light when he was elected state treasurer of Colorado in 1898. First National Bank vice president Joseph Gregory—who first took a position at the bank in 1917 and worked there until his retirement in 1958—is pictured here. The First National Bank remained a Glenwood Springs banking institution until 1987.

Citizen's National Bank. Several Glenwood Springs businessmen opened Citizen's National Bank in 1903, creating a new competitor for First National Bank. The Citizen's National building was completed in 1913 and located directly across the street from First National. Citizen's National competed with its rival for nearly three decades, but the bank was unable to recover from the stock market crash of 1929.

A Grand Building. The Citizen's National Bank building, designed by Denver architect Guy B. Robertson, held a prominent place on the southwest corner of Eighth Street and Grand Avenue. The interior of the bank was a thing of beauty, with marble teller cages, plastered ceilings, and mosaic tile floors. Pictured here inside the bank are customer Charles Barnes (left), teller George Bell (partially obscured in the background at center), and teller Fred Wirth.

Hopkins Hospital. In 1927, Dr. Granville Hopkins' dreams of a community hospital came to fruition when he purchased a home at 803 Bennett Avenue, added a west addition to the structure, and opened a 22-bed facility for treating the ill and injured. Hopkins embraced the use of x-ray machines and performed his first surgery in the Hopkins Hospital in October 1927.

St. Joseph's Sanitarium and Hotel

FOR PATIENTS AND CONVALESCENTS.

Neat Wards and Best of Nursing at Reasonable Rates. Private Rooms and Suites of Rooms that are arranged for Patients and Friends.

Address, SISTER SUPERIOR.
Glenwood Springs, Colorado.

ST. JOSEPH'S. Mary Whealan and Fannie Keating arrived in Glenwood Springs in 1898 with visions of opening a charity hospital. They purchased the Yampah Hotel at 802 Cooper Avenue and began renovations to create the St. Joseph's Sanitarium and Hotel. These sisters of charity had their hearts in the right place but had overestimated the demand for such an establishment and eventually lost the hospital to foreclosure. It closed in September 1900.

GRAND HOTEL. Pioneer Fred Barlow opened the St. James Hotel, also referred to as Hotel Barlow and the Yampah Hotel, in 1888. The four-story building was more than the market could bear, and Barlow lost it to creditors when he could not produce the income required to offset his expenses. In later years, the building housed St. Joseph's Sanitarium and Hotel and the Grand Hotel (pictured).

Hotel Glenwood. The beautiful brick structure known as Hotel Glenwood was completed in stages by owners William Gelder, Frank Enzensperger, and Isaac Cooper. They began by improving an existing wooden structure, which quickly proved too small, so they had to replace the building with something much larger. In 1886, two-thirds of the planned hotel were ready for occupancy. Construction was completed in 1887 at a cost of $150,000. The hotel boasted 60 rooms, a kitchen, a bar, a billiards room, elevators, and a fire-suppression system. The *Aspen Daily Times* called it an "object of pride" and "the finest hotel outside the City of Denver." Hotel Glenwood hosted a dinner for then–vice president Theodore Roosevelt in 1901, but its most infamous lodger was John Henry "Doc" Holliday, who died there in 1887. Ironically, the hotel burned to the ground in 1945 despite its touted fire-suppression system.

ROMA SALOON/REX HOTEL. The building on the corner of Seventh and Blake Streets had many names. By 1910, Bart Petrini leased the property from longtime saloon owner James Sheridan and managed the Roma Saloon as well as renting out rooms. When Colorado voters banned the sale of alcohol in 1914, the saloon became the Arcade Hotel. In 1920, Battista and Julia Anselmi purchased the property from Sheridan and renamed it the Rex Hotel.

STAR HOTEL BAR. Prior to the prohibition of alcohol, Glenwood Springs had as many as 30 saloons, including the Senate Bar, Mirror Saloon, Broadway Bar, Columbus Saloon, Silver Club, Bismarck, Pullman, and the Topic Bar. This photograph of the bar at the Star Hotel shows, in no particular order, Chet Everett, owner Mike Bosco, Hank Bosco, bartender Chuck Neehan, and Harry Straight (the man at right with the mustache).

STAR HOTEL. The mixture of buildings located across Seventh Street from the Denver & Rio Grande train depot included four saloons, two hotels, a restaurant, a grocery store, and a wholesale liquor business. The Bosco family immigrated from Italy and became instrumental in changing the face of this city block. Henry Bosco purchased property and built the Star Hotel on Seventh Street in 1915. Art Kendrick, owner of the Denver Rooms next door to the hotel, made his first addition to his business when Ryan's Restaurant burned, and he acquired that property. When Prohibition closed the saloons on the block, Kendrick purchased the saloon properties and added even more to his Denver Rooms. In 1938, Mike Bosco, who then owned the Star Hotel, purchased the Denver Rooms from Kendrick and combined the properties into the Hotel Denver.

HUGHES' WHOLESALE LIQUOR. Hughes' Wholesale Liquor distributed alcoholic beverages to local saloons and bars. Ed S. Hughes began his business by opening the Glenwood Bottling Works, where he bottled all types of aerated drinks, such as ginger ale, cider, sarsaparilla, and beer. As he became more successful, Hughes moved on to the distribution of liquor. This c. 1895 image shows a Budweiser wagon making a delivery.

ED S. HUGHES. Edwin S. "Ed" Hughes was raised in New Jersey and headed west after his he finished his formal schooling. He landed in Leadville, Colorado, where he learned the bottling trade from Isaac Hougland. Hughes later worked in the bottling profession for Charles Lang of Aspen. In January 1887, Hughes arrived in Glenwood Springs and started his bottling business there.

Deacon's Livery Stable. With horses being the primary mode of transportation, livery stables were needed to provide horses for customers, temporarily board horses, and provide feed and care for the animals. Deacon's Livery was located on Eighth Street between Grand and Colorado Avenues. Owners J.B. Deacon and Carl Hedrick are pictured here.

Ewing's City Drug Store. Druggist Fred Ewing arrived in Glenwood Springs in the 1880s and opened a drugstore on Grand Avenue. Ewing, a bicycle enthusiast, created an ice cream freezer that could be powered by peddling, which proved to be much faster than hand-cranking. In 1902, Ewing joined forces with another druggist, Charles Barnes, and they moved their drugstore to 731 Grand Avenue (pictured).

Glenwood Post. The *Glenwood Post* newspaper was the longest-running periodical in town. Amos J. Dickson purchased all of the newspaper's equipment, furnishings, and fixtures for $1,300 in 1897 and built the *Post* on a philosophy of providing a strong community paper without political influences. In 1897, subscriptions to the *Glenwood Post* were $1.50 per year, 75¢ per six months, and 5¢ per issue. Dickson printed columns for neighboring communities, advertised unclaimed letters at the post office, dedicated space to national and international news, and created the column "Pioneers I Remember," calling upon the old-timers in town to recount the city's history. Dickson was editor of the paper from 1897 until he retired in 1931.

FLOUR MILL. In the 1880s, Andrew J. Hyde built a flour mill along the banks of the Roaring Fork River to process grain grown locally. A railroad siding provided access for grain to be brought in from other regions. By September 1888, the mill was producing 50 barrels of flour per day. In 1908, Hyde and his partner sold the mill operation to the Farmer's Milling, Mining, and Mercantile Company.

YAMPAH FLOUR. The Farmer's Milling, Mining, and Mercantile Company sponsored a bake-off using their product, Yampah Flour, in 1910, which created a huge demand for the product. The Farmers Milling and Power Company, which purchased the mill in 1913, introduced a cracked-wheat breakfast cereal for sale in the local market. George Parmer (pictured) drove the Yampah Flour truck.

HEISLER'S HOME BAKERY. George Heisler and his wife, Sophia; daughter Thelma; and son Hans pose in front of their bakery at 728 Cooper Avenue in this c. 1910 image. The Heisler family owned one of many bakeries that supplied breads and pastries to the Glenwood Springs community in the early 20th century.

BIGHAM'S BAKERY AND GROCERY. Bread was a necessity on the frontier, and many women baked their own bread at home. Charles Bigham advertised his bakery at 906 Cooper Avenue by saying, "Bigham's bread and confections are the acme of purity and delicacy. You can buy them cheaper than you can make them."

BRYANT'S HAMBURGER STAND. While hamburgers may now be considered a staple of the American diet, they were a special treat in the 1920s, when Bryant's Stand was in business. Rosco "Roxy" Bryant was the founder and cook of the stand, located in the 700 block of Grand Avenue, which served large burgers accompanied by lettuce, tomatoes, and onions and wrapped in wax paper.

HYDE HALL. Entertainment has been a priority in Glenwood Springs since the 1880s, as shown by the number of entertainment halls, opera houses, and movie theaters located in the area. Hyde Hall was the first building in town built for entertainment purposes, followed by Durand's, the Isis Theater (which became the Orpheum), the Odeon, and the Paramount, to name a few.

ODEON THEATRE. This small building at 312 Seventh Street was enlarged before Durand's opened in the space in 1891. The hall was 50 feet wide by 80 feet long and accommodated conventions, presidential speeches, and a concert by John Philip Sousa and his band. Sometime in the 1920s, Durand's became the Odeon, which hosted a prize fight presented by silent-film star Tom Mix in 1926.

GLENWOOD HATCHERY. In 1905, Sen. Edward T. Taylor of Glenwood Springs secured the funding for a new fish hatchery on Mitchell Creek in West Glenwood, and local contractor William Dougan constructed the hatchery's building and spawn troughs. In the spring of 1906, the hatchery started production and distributed fry across the western slope of Colorado.

THE COMMERCIAL CAFÉ. Katie Bender's Commercial Café opened in 1886 and served the community for over 30 years. Bender's lunch counter offered generous portions of good food for 25¢ and remained open 24 hours per day and 7 days per week. Bender, also known as "Mother" Bender, showered her employees and the underprivileged with gifts and food. She and her husband, Joseph, came to Colorado from Missouri and originally opened a saloon. When Joseph died from heart problems at age 45 in 1888, he left Katie a widow with no surviving children, and she converted the saloon to a restaurant. "Mother" Bender also sold punch tickets for meals.

DOWNTOWN GLENWOOD SPRINGS. As the state bridge slopes over into the main section of downtown, a sign (at far right in the image) warns those crossing the bridge of a "$50 fine for driving or riding over this bridge faster than a walk." This photograph also shows the Broadway Bar, the Hotel Glenwood, a pharmacy, the Palace Rooms, and the Silver Club.

KECK'S GARAGE. When automobiles arrived in Glenwood Springs in the 1910s, they were soon followed by gas stations, service garages, and car dealerships. This photograph shows Keck's "Fire Proof" Garage, where one could take a vehicle for maintenance. The Rose Motor Company, located across the street, opened in 1925 and sold Chevrolets.

ATTORNEY ARTHUR BEARDSLEY. Arthur Livingston Beardsley arrived in Glenwood Springs in 1887 after traveling by coach from Aspen. He had visited the town in 1885, just prior to enrolling in law school at the University of Michigan; he liked what he saw and returned to set up a law practice. Beardsley kept a diary of the time he spent in Glenwood Springs, which offers a special glimpse into the early days of Glenwood.

KAISER HOUSE. The beautiful home of Fred and Aura Kaiser was constructed in 1902. The Kaisers married in 1899, and Fred worked as an electrician for the Glenwood Light and Water Company. The home is located at 932 Cooper Avenue, directly across the street from the Christian Science church, where Aura Kaiser was a practitioner.

NAPIER'S DRY GOODS STORE. Barnette T. Napier—"Barney" to most—sought out the dry climate of Colorado in hopes of curing chronic respiratory problems. A well-read man, Napier had studied law at the University of Missouri and used this knowledge to obtain teaching positions. He spent seven years in Boulder learning the dry goods business before striking out for Leadville and Aspen. While in Aspen, he became a grain and feed supplier and made enough money to start his own dry goods business. He arrived in Glenwood Springs in 1886 and opened B.T. Napier and Co., selling hats, suits, dresses, fabric, notions, curtains, and towels. He served as mayor of Glenwood Springs from 1901 to 1902 before serving as a Colorado state legislator for 14 years.

MASONIC LODGE. Even though the Masons had existed in Glenwood Springs since 1887, they did not build their own permanent lodge until 1927. In this photograph, they are setting the cornerstone for the Glenwood Lodge No. 65 building on Colorado Avenue. The lodge provided assistance for public education, the aged, the orphaned and widowed, and the less fortunate.

SURVILLE JEAN DE BAPTISTE DELAN. DeLan, a native of the West Indies, traveled to Colorado purely for pleasure. Once he experienced the excitement in the mining community of Leadville, he stayed. He was appointed to run the US Land Office in Glenwood Springs after a stint serving as marshal of Colorado's Supreme Court. He served as mayor of Glenwood Springs from 1902 to 1912.

75

Carrie Nation Pays a Visit. In 1888, the riverfront "sporting district" of Glenwood Springs housed as many as 22 saloons, liquor distributors, and establishments that sold spirits. One of these establishments, Sheridan's Saloon, is pictured here around 1914. The men at the bar are, from left to right, Jim Hogan, Jerry O'Shea, Pat Hayes, bartender Clyde Yates, Jack Flynn, Tom Sugrue, and an unidentified man. In 1903, Carrie A. Nation, a zealous supporter of Prohibition, visited Glenwood Springs. Nation was well known for carrying three hatchets—she called them Faith, Hope, and Charity—that she wielded in saloons around the country in an effort to promote temperance. Saloon owners in town maybe should have been worried, but Nation arrived on a Tuesday in April that had been set aside as an election day, so all of the saloons were closed to allow the men who usually frequented the bars to vote. Upon realizing this, Nation headed back to the railroad depot, where she gave a speech to residents who had gathered there.

Four

Bring in the Tourists

On April 27, 1891, the new bridge across Grand River was dedicated in an impressive grand ceremony held in conjunction with a celebration of the 72nd anniversary of the Independent Order of Odd Fellows. Downtown was beautifully decorated, food and drink was served, and a parade traveled through the streets. Gov. John Long Routt was invited, but to the disappointment of many, he was unable to join the festivities. Mayor J.L. Hodges welcomed the attendees with this speech:

> The occasion of this assemblage is the celebration of the opening of our state bridge across the Grand river, as well as the 72nd anniversary of the establishment of the Order of Odd Fellows of America.
>
> Permit me to say that, only a few years since, this place was the hunting ground and home of the Ute Indians . . . This country became open to occupation as other public lands on July 28, 1882.
>
> Before that time and for a while afterwards this valley, including our town, was practically inaccessible. The Indian could get here with his pony, the hardy pioneer who recognized no obstacle, could get here with his faithful jack.
>
> This Grand river, which rolls its torrents by our side, and, whose eternal roar now partially drowns our voices, was closed above and below on either side by the everlasting mountains. The Roaring Fork near by, whose borders are marked by the richest mining camps in the world, and its branches, all have their sources on the western slopes of the highest portions of our Rocky mountains.
>
> This valley is surrounded by high rugged and it might be said impassible mountains. It is true, the ingenuity and indomitable will and energy of man, aided by vast capital, has opened through our Grand river and Roaring Fork valleys, thoroughfares leading from the Atlantic to the Pacific.
>
> As a community, as a town; we are young. We think we have just entered our career among other Colorado towns and cities. We believe we have a grand future. We are full of hope, and anticipation. And though our town is so young, we are not without some realization of former anticipations.

GLENWOOD CANYON. When settlers first arrived in the area, Glenwood Canyon was naturally impassable. The Grand River (now the Colorado River), cut through the canyon cliffs and left little room for a horse or wagon trail. Instead, travelers crossed the Flat Tops north of the canyon and descended into Glenwood Springs via Transfer Trail. This photograph shows the first crude road, which was built through Glenwood Canyon in the late 19th century.

A RIVER RUNS THROUGH IT. Actually, two rivers run through Glenwood Springs: the Colorado and the Roaring Fork. The Colorado bisects the town into north and south. Since the Flat Tops and the hot springs were located in the northern section, pioneers used rafts and ferries to cross the river. The ferry shown in this photograph was called the *Polly Pry*.

COOPER TOLL BRIDGE. Isaac Cooper constructed a wooden bridge over the Grand River in 1883. He set rates at $1 for wagon teams, 25¢ for saddle and pack animals, 15¢ for cattle and sheep, and 10¢ for those on foot. In the spring of 1884, after heavy runoff from a massive winter snowfall washed out the bridge, residents petitioned Garfield County commissioners to reconstruct the crossing.

STAGE LINES. Travelers could head to Glenwood Springs via the Flat Tops or an alternate route from Leadville and Aspen. As early as 1883, the Carson Stage Line and the Western Stage made trips between Aspen and Glenwood Springs to take passengers and their baggage to the hot springs. Later, mail service was added to the stage runs several times per week.

GRIZZLY CREEK. The drainages of No Name and Grizzly Creeks have long been popular with hikers and fishermen. In the late 1880s, the City of Glenwood Springs began diverting water from these creeks—before they run into the Colorado River—to support the city. This photograph of Grizzly Creek was taken by local photographer August Dennis around 1890.

MODES OF TRANSPORTATION. When Glenwood Springs was being settled, wagons, carts, and buggies of all shapes and sizes pulled by horses, mules, and donkeys were the primary means of conveyance. The city hired a town scavenger—an official title—to clean up after the animals. These residents posed for a photograph on Bennett Avenue at its intersection with Tenth Street.

TALLY-HO. The Tally-Ho wagon was a horse-drawn excursion vehicle used to transport visitors around Glenwood Springs. It would make stops at local hotels and transport guests wherever they needed to go. The main compartment of the wagon had three rows of seats. Additional riders could sit in the back row—much like a rumble seat in an automobile—or share a seat with the driver.

SLEIGH RIDES. The winter snows created challenges in getting around town. These obstacles could be somewhat overcome by using sleighs for transportation. This sleigh, owned by William Cardnell, is pictured with horses Prince and Sister. Sleigh riders stayed cozy by using lap blankets to cover themselves.

A SERIES OF IMPROVED ROADS. In 1890, Henry Morrow improved the road through Glenwood Canyon by utilizing the rail bed that had been started by the Burlington Railroad and abandoned when the company faced construction difficulties and cost overruns. In 1899, Colorado state senator Edward T. Taylor obtained an appropriation of $60,000 to construct a road from Denver to Grand Junction. The Taylor State Road was largely completed in 1902, with a good portion of the appropriation being used in Glenwood Canyon (left). Taylor, a permanent resident of Glenwood Springs, felt that a reliable, all-weather road was important for access to the community. By 1911, the road needed further improvements, which workers (below) completed in 1920.

ARRIVAL OF THE TRAINS. Before 1887, the Denver & Rio Grande and Colorado Midland Railroads engaged in a competition to be the first railroad to reach Glenwood Springs. The Rio Grande made its way through Glenwood Canyon as the Colorado Midland was building track from Aspen and Basalt. The Rio Grande arrived first—in October 1887, and the Midland reached Glenwood Springs in December of that same year.

RAILROAD BRIDGE. The Colorado Midland and Denver & Rio Grande Railroads came into town and met at a wye where Seventh Street meets the Roaring Fork River. A railroad bridge constructed across the Grand River, as well as track laid through West Glenwood, took railroad travelers to points west.

A TALE OF TWO DEPOTS. When the Denver & Rio Grande and Colorado Midland Railroads arrived in 1887, Glenwood Springs had a wooden depot building (above) at Seventh Street and Pitkin Avenue. It served the community until the early 1900s, when residents decided that Glenwood Springs needed a depot befitting the expectations of the wealthy travelers who visited the community. The city of Glenwood Springs donated land and broke ground for a new depot (below)—located at Seventh Street between Cooper and Blake Avenues—in May 1903. The architect who created the bathhouse at the hot springs, Theodore Von Rosenberg, designed the depot to complement the style of architecture at the Hotel Colorado, using Peachblow sandstone and installing cupolas at the entrance that mimicked the bell towers of the hotel.

WATER TANK. This water tank, located on Seventh Street between Colorado and Pitkin Avenues, served the steam engines that traveled through town. The state bridge and the Hotel Colorado bell towers are visible in the background. The railroad crossing sign warns those on horseback or foot to "look out for the cars."

AVALANCHE DANGER. Huge amounts of snow fell in the winter of 1899, causing a 200-foot-wide snow slide to cover the tracks through Glenwood Canyon. A passenger train hit the avalanche, telescoping cars, but not before the engineer threw the train into reverse and jumped to safety. A 100-man crew had arrived to dig out the tracks when a second slide covered the wrecking train that had come to help.

DOTSERO TRAIN WRECK. In January 1909, two trains collided at Dotsero, just east of Glenwood Canyon, killing 26 and injuring 33. Engineer Gus Olson was driving a passenger train and had been warned to wait on the siding while a freight train passed. Olson either did not receive or did not heed the warning, and his train smashed head-on into the freight train, which was manned by engineer Sig Olsen.

FIRST FORDS. In April 1910, the Glenwood Springs Motor Club ordered seven Ford automobiles to be delivered to members. The drivers of these cars included Dr. D. Pletcher, H.O. Yewell, Charles Hughes, Jack Vories, and Dr. W.F. Berry—all from Glenwood Springs—along with W.H. Hale and C.M. Donnell of Rifle. The cars and their drivers are pictured here in front of the White Elk Museum on Grand Avenue.

ON THE ROAD. The old stage road between Aspen and Glenwood Springs followed about 40 miles of the Roaring Fork River. In the days of stagecoaches, the trip took at least two days—with an overnight stop at Mrs. Garrison's in Emma. The trip took much less time in an automobile. This Ford is sitting along the road that would become State Highway 82.

ELECTRIC BUS. In 1914, Jesse C. Dewey purchased an electric bus as a means to upgrade his transfer business. He ordered the bus, manufactured by General Electric, through the Glenwood Light and Water Company. Electric vehicles, which were common at the time, provided a quieter car with easier shifting and starting. Dewey used the bus to transport guests of the Hotel Colorado.

AIRPLANES. In August 1919, curious Glenwood Springs residents gathered at the polo grounds south of town and rows of automobiles lined Grand Avenue from the city limits to the polo grounds where, after months of anticipation, four De Havilland biplanes were set to land. These were the first airplanes to come to Glenwood Springs. Eight aviators from the Transcontinental Aerial Squadron were to fly four planes into town from Grand Junction. The first plane came from

the south and was piloted by Lt. Erick H. Nelson and Sgt. J.J. Kelly. Two more planes landed at the polo field that day; the fourth, piloted by a Lieutenant Nutt, got lost and landed in a pasture outside of Carbondale. The crowd became so excited about witnessing airplanes firsthand that the machines had to be roped off to keep people from damaging them. These magnificent airmen and their flying machines were based out of Ellington Field in Houston, Texas.

PROVING THEIR WORTH. Before they arrived in Glenwood Springs in August 1919, the airplanes of the Transcontinental Aerial Squadron were on their longest trip yet as part of the US Army Air Service. They had logged over 4,000 miles at an average speed of 100 miles per hour. They left Houston, flying along the Mexican border to San Diego, California, then north, over the redwood forest, to Reno and Lake Tahoe, Nevada. From there, they flew to Salt Lake City, where they transported $108,000 in cash from local banks to the federal clearing house—an exercise designed to demonstrate that air travel could be beneficial to business. After staying in Glenwood Springs for several days, the pilots left for Denver, making the 128-mile trip in about 90 minutes.

SHOSHONE POWER PLANT. In 1905, the Colorado Power and Irrigation Company secured first water rights on the Grand River with plans to build a hydroelectric power plant at Shoshone Falls. Unable to implement their plans, in 1906 they sold them to the Central Colorado Power Company, which was building a network of plants throughout the region. Using the natural elevation drop in Glenwood Canyon, the company constructed a 12,450-foot diversion tunnel through the mountain in the cliffs above the river, then built a dam and diverted water through the tunnel to the power plant. Two high-pressure penstock pipes dropped the water to the plant, where two 9,000-horsepower turbines and two 5,000-kilowatt alternating current generators created electricity. The Shoshone plant generated its first power for public consumption in 1909.

SHOSHONE COMMUNITY. Nearly 1,500 people worked on constructing the Shoshone hydroelectric plant and dam. The Central Colorado Power Company provided housing (a camp located at Cinnamon Creek on the south side of the river), meals, and medical care for their employees. The company built an apartment complex to house married couples, and the camp contained a post office and a school. Building the power plant and dam was dangerous work, and several workers were injured—and even killed—during construction. Poor living conditions in the camp may have led to some of the accidents, so the company eventually brought in a new camp manager to make improvements.

CAÑON OF THE GRAND. Glenwood Canyon proved to be an obstacle in the early days of the community, but one that was overcome as the Central Colorado Power Company harnessed the Grand River for the benefit of the townspeople. In 1921, the Colorado General Assembly approved legislation that changed the river's name from the Grand to the Colorado. Through the efforts of Congressman Edward T. Taylor, federal legislation also approved the change.

ENTERTAINMENT OR DANGER? The beauty of Glenwood Canyon is unsurpassed, but the river has had its share of tragedy. In 1884, Garfield County lost its first elected sheriff, Andrew Rock, to the turbulent waters. In 1905, R.H. Fishbeck saw the river as an opportunity and became the first person to successfully navigate the river by boat, foreshadowing a booming rafting industry.

HORSEPOWER. This interesting vehicle is parked behind Cardnell's Autos in the 800 block of Colorado Avenue. The automobile—presumably inoperable—is being pulled by two horses. A buggy attached to the rear of the car is possibly providing extra seating for passengers. Bert Cardnell is the gentleman seated in the automobile.

WAGON HO! In this 1920s photograph, a group of adventurers has loaded up a wagon for a summer of hunting, fishing, and camping on the Flat Tops. This photograph shows that even with the advent of automobiles, some people still preferred old-fashioned modes of transportation. With the area's steep, rough, and rutted roads, mules, horses, and wagons were definitely an acceptable alternative to automobiles.

Five

(In)famous Residents and Visitors

Glenwood Springs has been a home and/or a vacation spot for many who could be considered famous—or infamous. One of the area's most interesting residents was a Chicago gangster named Louis Verain, aka "Diamond Jack Alterie"; the reason for his exit from Glenwood Springs is detailed in this *Glenwood Post* article from 1932:

> Alterie came to the Western Slope about five years ago, when he purchased the Sweetwater lake resort and attempted to run a dude ranch. His career at the lake was not successful and was marked by more or less trouble. A quarrel at the lake between himself and a brother resulted in Alterie's being wounded by a gunshot wound. In another quarrel he smashed up two guests with a gun and his fists, for which he was not prosecuted.
>
> For several weeks this fall he had made the Denver hotel in Glenwood his home, and early last month, while drinking, he went on a rampage. He was given a severe beating by a companion, following which he armed himself. When disarmed by a hotel porter, he secured other guns and beat the porter up badly, using the butt of his gun. He then wounded two guests when he shot through their bed room door.
>
> After having laid in the Garfield county jail for a month . . . Jack Alterie, alleged Chicago gunman, appeared before Judge Shumate of the Garfield county district court last Thursday and plead guilty to two of the counts against him.
>
> Judge Shumate . . . sentenced him to serve a sentence of one to five years in the penitentiary . . . Judge Shumate then suspended the penitentiary sentence provided the defendant would immediately leave the Western Slope, and the state of Colorado before February 1 and remain away from the state for the maximum length of the prison term—five years. Alterie accepted the banishment sentence.

Chief Eggleston. In the fall of 1901, local attorney Charles Darrow successfully defended a Ute man known as Chief Eggleston against charges of being involved in a large-scale poaching operation. Eggleston had been arrested in neighboring Rio Blanco County by a game warden from Garfield County, and Darrow argued that the game warden was out of his jurisdiction when he made the arrest. The judge agreed and released Eggleston and returned his personal property, including horses, rifles, and deer hides. Eggleston is shown in this photograph with two of Darrow's children, Nicholas (left) and Helen. Charles and Elizabeth Darrow married in 1885 and had 14 children. Upon moving to Glenwood Springs, Charles was hired by the Colorado Midland Railway to negotiate right-of-way purchases. He also represented the Grand River Coal and Coke Company and served as city attorney. Charles Darrow served as mayor of the city of Glenwood Springs from 1919 to 1920.

"The Charitable One." Chipeta, the respected wife of Ute chief Ouray, outlived her husband by 44 years. Her name is said to mean "the charitable one" or "white singing bird." She is pictured at the Hotel Colorado with a man identified as Mr. Chase (center) and the Ute McCook. Chief Ouray served as an interpreter and negotiator for the Tabeguache band of the Ute during treaty negotiations in the 1860s and 1870s. In 1880, Ouray died of a kidney ailment called Bright's disease. Chipeta lived on her farm on the Uncompahgre River until the government opened up Ute lands to white settlers and forced Chipeta and her tribe onto reservation lands in eastern Utah. She lived a simple life and refused government aid. As she aged, she was plagued with rheumatism and failing eyesight. Cataract surgery provided temporary relief, and she visited Hot Springs Pool on several occasions. Chipeta died in 1924 on the Uintah Reservation in Utah.

The Visiting President. On May 10, 1891, Pres. Benjamin Harrison's train pulled into Glenwood Springs for a brief visit. He breakfasted at the Hotel Glenwood, where he met with Gov. John Long Routt and Glenwood Springs officials. Mason Mather, manager of the Hot Springs Pool, gave Harrison a tour of the facilities while members of the president's entourage took a swim.

Presidential Gifts. When Pres. Benjamin Harrison visited in 1891, the community presented him with a beautiful gold-and-silver plate as a gift from the community. The women of the town presented First Lady Caroline Harrison with an album containing images from the area. The president and his family attended church services at the First Presbyterian Church. The president's train departed Glenwood Springs in the afternoon.

THE INFAMOUS DOC HOLLIDAY. John Henry "Doc" Holliday was a Southern gentleman who was well educated and became a doctor of dental surgery at the Pennsylvania College of Dental Surgery in Philadelphia, Pennsylvania. After graduation, Holliday practiced in Atlanta, Georgia, before being diagnosed with tuberculosis. His uncle, a medical doctor, advised him to move west, where the air was drier, so Holliday boarded a train to Texas. He hung out his shingle and practiced dentistry until the continual coughing caused by his disease made it impossible. He often dealt cards as a means to make a living. Holliday was probably best known for his involvement with the Earp brothers in the 1881 gunfight at the O.K. Corral in Tombstone, Arizona. He arrived in Glenwood Springs on a stagecoach in the spring of 1887. His lungs were riddled with consumption or tuberculosis, and he was presumably seeking relief in the waters of the hot springs.

Hotel Glenwood. While in town, Doc Holliday took up residence at the Hotel Glenwood. He supposedly dealt cards and may even have attempted to practice dentistry as a source of income in the six months he was in Glenwood Springs. However, his disease had progressed to the point where he fell into a coma for several weeks before succumbing on November 8, 1887. A funeral was held at the First Presbyterian Church at 4:00 p.m. that day, with Rev. W.S. Rudolph presiding. Holliday was buried in Linwood Cemetery, which was established only one year prior. Since Holliday was destitute when he died, he most likely was buried in the potter's field section of the cemetery, which was reserved for indigent people. He may have been afforded a wooden marker at the time, but even if so, it has long since disappeared. The cemetery records have been lost, and Holliday's final resting place disappeared along with them.

The Honorable Edward T. Taylor. Glenwood Springs resident Edward T. Taylor, an attorney whose career took him into politics, was elected to the Colorado Senate in 1896 and the US House of Representatives in 1908. He secured funding for the road through Glenwood Canyon and worked to protect Colorado's water and conserve federal lands through the Taylor Grazing Act. After serving in the legislature for 54 years, Taylor died in 1941.

Hunting with the President. Theodore Roosevelt, an avid outdoorsman, spent time hunting on the Western Slope of Colorado. In 1905, he hunted on East Divide Creek near Glenwood Springs just a few months after his presidential inauguration. Roosevelt employed Jake Borah, John Goff, and Al Anderson as guides for the hunt. Pictured here are Philip B. Stewart (left), Dr. Alexander Lambert (center), and Roosevelt.

IT TAKES A VILLAGE. Many people helped to ensure that President Roosevelt's hunt was a success, from guides and cooks to photographers who captured it for posterity. Gathered around the lunch table at hunting camp are, clockwise from left, Al Anderson, Brick P. Wells, Jake Borah, Jack Fry, Pres. Theodore Roosevelt, Alexander Lambert, John Goff, C.W. Allen, and G.M. Sprague.

A SUCCESSFUL HUNT. Following the hunt, during which the president and his party reportedly bagged 17 bears and three lynx, the group returned to Glenwood Springs on horseback. Many locals greeted them as they rode through West Glenwood toward the west entrance of the Hotel Colorado. Businesses closed for the day to allow everyone the opportunity to catch a glimpse of the president.

SPEAKING TO THE CROWD. On the evening of May 6, 1905, after returning from the hunt, Pres. Theodore Roosevelt spoke to a crowd of citizens gathered on the lawn of the Hotel Colorado. The president, dressed in formal attire, was accompanied on the platform by Glenwood Springs mayor and business owner W.S. Parkison.

THE PRESIDENTIAL BALCONY. On his last full day in Glenwood Springs, Roosevelt attended services at the First Presbyterian Church, which had been beautifully decorated in red, white, and blue. He was allowed to worship quietly with the congregation. After visiting Frank Hayes's taxidermy shop, where the animals garnered during Roosevelt's three-week hunt were taken for processing, the president again spoke to a gathered crowd from the balcony of the Hotel Colorado.

Hotel Colorado...

PRESIDENT THEODORE ROOSEVELT

Theodore Roosevelt

Sunday May 7th, 1905

Menu
Hotel Colorado

Sunday – May 7th, 1905

Canape Caviare

Consomme Rothschild — Green Turtle, Manzanilla
Lettuce — Ripe Olives — Spiced Pickles — Salted Pecans

Spanish Mackerel, Perigord
Potato Beignets

Veal Sweetbreads Glace, Petits Pois
Fresh Mushrooms on Toast
Small Patties, Toulouse

Roast Prime Beef, au Jus
Young Turkey with Dressing, Cranberry Sauce
Spring Lamb, Mint Sauce

Mashed Potatoes — New Potatoes in Cream
Asparagus, Drawn Butter
New String Beans — Green Peas

Frozen Egg Nogg

Broiled Squab with Bacon

Lettuce and Tomatoes Mayonnaise

Nesselrode Pudding
Apple Pie — Cream Puffs
Charlotte Glace
Strawberry Ice Cream — Assorted Cake

Apples — Bananas — Tangerines — Figs — Nuts and Raisins
American, Sierra or Roquefort Cheese
Toasted Crackers

Demi Tasse

Roosevelt's Banquet for Hunters

A Party for the Participants. Pres. Theodore Roosevelt held a banquet on May 7, 1905, at the Hotel Colorado to honor the men who had made his hunt a success. The dress for most of the participants was casual, and the event was held in a private dining room. The guides wore flannel shirts, set aside their guns, and removed their chaps. The president and presidential secretary William Loeb wore frock coats, and Dr. Alexander Lambert and Philip Stewart—members of the hunting party—wore business suits. The official menu for the evening is shown here. The attendees shared stories of the hunting trip with the caveat that the tales would not leave the dining room. When the festivities concluded, the president returned to his personal train car, the *Rocket*, for the night. He and his entourage took their leave before dawn the next morning.

A Western Showman. William F. Cody, better known as "Buffalo Bill," frequently visited Glenwood Springs. The former scout—who found fleeting success with his Wild West show—often visited his longtime friend Dr. W.W. Crook, who resided and practiced medicine in Glenwood Springs. Cody is pictured here with Dr. Crook (right) in front of the bathhouse at the Hot Springs Pool in January 1917.

Physician's Care. The bathhouse, where Dr. Crook maintained his office, contained private rooms where patients could convalesce under the doctor's care. Cody was reportedly seeking relief from an undisclosed illness when he came to visit. He also may have been in town to say his last good-byes to his dear friend. Cody passed away just a few days after visiting Dr. Crook in Glenwood Springs.

HOLLYWOOD COMES TO GLENWOOD SPRINGS. Silent movie star Tom Mix—along with his family, 55 crew members, and 22 horses (including Tony the Wonder Horse)—arrived in Glenwood Springs in July 1926 to film *The Great K & A Train Robbery*. Mix, his family, and about half of the crew resided at the Hotel Colorado during the three weeks of filming.

DAMSEL IN DISTRESS. Dorothy Dwan, Tom Mix's costar in *The Great K & A Train Robbery*, was his leading lady and love interest in the movie. She appeared in several of Mix's movies, reportedly taking any roles she could in an effort to pay off a large debt incurred by her husband.

GRACIOUS HOSTS AND APPRECIATIVE GUESTS. At a time when movie stars were eyed with skepticism by many, Tom Mix and his crew worked hard to assure the residents of Glenwood Springs that their intentions were honorable. In a show of good will and to thank the town for their hospitality, Mix and his crew presented the town with a variety show, a rodeo, and a boxing match.

CONVERSING ALONG THE TRACKS. Tom Mix (left) is shown here in full costume and makeup with fellow actor Harry Grippe, who played a bum named DeLuxe Harry in the movie. They are standing along the railroad tracks in Glenwood Canyon, where much of the movie was filmed. Another actor, Buster Gardner, fell in love with Glenwood Springs and stayed after filming, calling it home until his death in 1957.

DIAMOND JACK ALTERIE. Chicago gangster Leland Verain, aka Diamond Jack (or "Two-Gun") Alterie, posed for this photograph in his typical Western attire, including a white ten-gallon hat. His nickname was reportedly derived from his large, diamond-studded belt buckle. Alterie ran the Sweetwater Lake Resort as a dude ranch for a time in the late 1920s.

JUST DESSERTS. Alterie tried to fit in with the Glenwood Springs community, but he was banned from the state of Colorado after an altercation at the Hotel Denver during which two men were shot. He returned to Chicago, Illinois, where he had been a hit man for Dean O'Banion's South Side Gang. Alterie was gunned down on the streets of Chicago in 1935. This image shows a Christmas card mailed by Alterie and his wife.

Wishing you a very merry Christmas and a bright and happy New Year

Mr. and Mrs. D. J. Alterie

Six

Recreation, Events, and Celebrations

The options for entertainment in Glenwood Springs have always been numerous. The Strawberry Day (now Strawberry Days) festival is a homegrown event that began on June 18, 1898, and has been observed every year since (with the exception of several years during World War II). An article in a special Strawberry Day edition of the *Avalanche* describes the first year of the event:

> We have started—The first Strawberry Day for Colorado and for Glenwood Springs has been launched and was a success in every sense of the word.
>
> Nothing marred the festivities of the day and Glenwood added to her long list of callers, many who will visit us often and who are ready to swear by our hospitality.
>
> The arrival of the Colorado Midland band was the signal for the beginning of the day's festivities. Trains from the east, west and south were loaded and they all wanted strawberries and cream and a swim and they got it and seemed to be well pleased with everything.
>
> The swimmers in the pool were numerous from early morn till night. The children, old folks, young folks and all kinds of folks, swam and dived and rolled about in the water to their hearts content. They made the best of the free swim and they made everyone happy because they enjoyed it.
>
> The decorations of the city were elaborate and many surprised themselves in the good work they did in this line. There was nothing too good for Glenwood's first Strawberry Day so the American flag floated everywhere.
>
> It was the women of Glenwood and the country around here that made the day a success. It was their hands that prepared the strawberries, the cream, the cake and dished the same to the people who came here to eat.
>
> The number of wagons that came in were loaded down with farmers and their wives and children. They were so numerous that if they were strung out it would be a continuous procession from Cardiff to the state bridge.

THE OUTDOOR LIFE. Although hunting and fishing were originally a necessity to sustain one's life and the lives of one's family members on the frontier, by the 1890s, frontier residents became more focused on recreation than survival. Deer, elk, bear, and mountain lions were available in abundance to satisfy the adventurous hunters. Outfitters and guides led many greenhorns—as well as experienced outdoorsmen—into the wilderness to take advantage of the opportunities to enjoy everything nature had to offer. Popular local pastimes included horseback riding, camping, hunting, and fishing. Located at the confluence of the Grand (Colorado) and the Roaring Fork Rivers, Glenwood Springs is still a prime fishing location. Railroads such as the Colorado Midland or Denver & Rio Grande advertised a stop here for hopeful anglers.

CAVES OF WONDER. The hillsides surrounding Glenwood Springs are filled with caves. After being discovered by Charles Darrow and his family, the Fairy Caves—located in the Iron Mountain behind the Hotel Colorado—became one of the largest known cave systems in the area. In 1895, Darrow opened the caves to the public for tours. By 1897, he had strung electric wires up the mountain to light the caves with colored bulbs, giving them a fairylike appearance.

CHARLES DARROW. Darrow (standing at left) and his family discovered and developed the Fairy Caves, giving tourists yet another reason to visit Glenwood Springs. Advertisements labeled the Fairy Caves the "Eighth Wonder of the World," and they became one of the most popular attractions in town.

CAVE OF THE CLOUDS. In 1885, a railroad surveyor discovered this cavern, which has multiple rooms, when he witnessed a rockslide while waiting for work orders and made the 500-foot climb up the canyon wall to investigate. A look inside the entrance to the cave revealed stalactites and stalagmites; "Alexander's Cave" opened for public tours by August 1887. In 1893, owner Frank Mason renamed it "Cave of the Clouds."

COWBOY BAND. The Glenwood Springs cowboy band formed in 1911 and included some of the town's most talented musicians, who dressed in cowboy attire and employed a miniature stagecoach pulled by four horses. It took two men to carry the enormous brass drum when the band participated in parades such as those at the local Strawberry Day celebration and the Festival of Mountain and Plain in Denver.

BASEBALL, 1907. The boys of summer took a place in Glenwood Springs history much as they did in the rest of the country. Baseball gained popularity locally in the early 1890s, with businesses such as B.T. Napier and Company sponsoring teams. Glenwood Springs sponsored a professional exhibition game between the Baltimores and the All Americans in November 1897.

FOR THE LOVE OF THE GAME. The town team's home games took place at the field at the west end of Eighth Street. The town hosted teams from Leadville, New Castle, and Aspen, as well as teams from mining camps around the area. In 1910, a fledgling town team competed against the experienced players from the high school team, resulting in the town team losing 15-3.

OUR SUMMER FESTIVAL. The Tri-County Farmer's Union proposed the first Strawberry Day in 1898 as an event to promote local fruits, vegetables, and dairy products. The Tri-County Farmer's Union covered communities from New Castle to Parachute, Glenwood Springs to Eagle, and Carbondale to Aspen. For the event, farmers would provide the strawberries and fresh cream while Glenwood Springs would play host.

FEED THE CROWDS. Strawberry Day was the perfect melding of agriculture and tourism. The women of Glenwood Springs served slices of homemade cake, which was topped with sweet strawberries from the farmers' fields and drowned in fresh cream. In 1910, attendees gathered at long tables set up in the streets to serve the festival's namesake strawberries to locals and visitors alike.

BEAUTIES OF THE FESTIVAL. In 1913, the Strawberry Day committee added a queen contest to the annual strawberry festivities. That year, 14 young women from Glenwood and the surrounding communities of Aspen, Marble, and Carbondale competed for the honor, and Ruby Clarke reigned victorious. The third Strawberry Day queen, Ada Hutchings, is pictured here in 1915.

EVERYONE LOVES A PARADE. A parade has been a primary component of the Strawberry Day festivities for many years. This mid-1910s float shows "King Strawberry" driving a barge decorated with strawberries and cream cans and topped off with youngsters—dressed as chefs and strawberries—in a crepe paper basket. The parade route normally wound its way up and down Grand and Cooper Avenues.

PROMOTING BUSINESSES. Some parade participants were not afforded a float to ride on but walked the route with signs advertising towns or businesses. These young ladies from the town of Cardiff are decked out in their Strawberry Day finest. Merchants sold souvenir pins and spoons and produced postcards to commemorate each year's event.

SOMETHING FOR EVERYONE. Strawberry Day attendees could enjoy a wide variety of activities, including baseball games, swimming, performances by bands, evening balls, flower displays, and the queen contest. The festival offered something for everyone of every age and was a time to celebrate community and show the world that Glenwood Springs was a successful town.

BICYCLE RACE. In August 1898, the Colorado Midland Railroad sponsored Roaring Fork Valley's first bicycle road race, which took riders from Basalt to Glenwood Springs—a distance of 24 miles. Will Broughton won the first race. At the finish line, spectators could enjoy entertainment. In 1911, Denver's Amos Hughes descended a flight of stairs (pictured above) on his bicycle in what was called a suicide ride, successfully making his way to the bottom only to hit a rock and crash; this was Hughes' second time performing the trick (the first time being at Elitch Gardens in Denver). He arose from the ground bruised but otherwise fine. The next year, the entertainment included a tightrope walker who performed tricks and crossed the Grand River on a wire.

HANGING LAKE. This emerald lake "hanging" on the side of Glenwood Canyon a few miles east of Glenwood Springs has been a tourist attraction since the early 20th century. The 1.2-mile trail to the lake follows Dead Horse Creek and rises more than 1,000 feet. The view is well worth the hike.

HOMESTEADER THOMAS F. BAILEY. Bailey filed a homestead on the Hanging Lake property in the early 1900s and promoted it to tourists during the summer months. He began to lose control of his land when it was absorbed by the Holy Cross National Forest. He attempted to hold onto the land by claiming its use as agricultural, but after two years of appeals, he lost the land in 1912, and control reverted to the federal government.

A CITY PARK. In 1910, local congressman Edward T. Taylor sponsored a federal act allowing cities to purchase federal land for parks. In 1912, the city of Glenwood Springs passed a resolution to purchase Hanging Lake as a city park for $1.25 per acre. The city held the land until 1972, when they let the title to the property revert back to the federal government.

FALLS BELOW HANGING LAKE. In 1934, the local company of the Civilian Conservation Corps worked to improve the trail to Hanging Lake as one of their first assignments in the area. They constructed a wooden shelter and several footbridges. From 1945 until 1968, Hanging Lake Park managers Dub and Wanda Danford rented cabins and operated a restaurant at the base of the trail.

PATRIOTIC DOINGS. In April 1917, Glenwood Springs celebrated the Monday following Easter in patriotic fashion—Mayor Ollie Thorson had a 55-foot flagpole planted in the intersection of Ninth Street and Grand Avenue for a flag drill performed by the youth of Glenwood Springs. World War I was in progress, and this was the community's way of honoring those who were fighting overseas.

THE LITTLE TANK THAT COULD. *Little Zeb*, a tank used during World War I, is pictured here in April 1919. This war machine toured the country in an effort to promote the sale of war bonds to alleviate the debt incurred by the United States during the war. The tank rolled around town, displaying its maneuverability, with the citizens of Glenwood Springs following behind it.

THE SPORT OF KINGS. A polo field established just south of the townsite of Glenwood Springs hosted its first match on the day of the grand opening of the Hotel Colorado—June 10, 1893. Pictured here in 1905 are, from left to right, Glenwood Polo Club members William G. Devereux, F. Hervey A. Lyle, Stephen Baxter, and Thomas Baxter. The Glenwood polo team was quite successful throughout the 1890s.

THE CLUBHOUSE. Spectators at the Glenwood Polo Club observe a polo match in 1912. The Glenwood Polo Club played against teams from the Denver Country Club, the Colorado Springs' Cheyenne Mountain Country Club, Fort Logan, and Fort Robinson in Nebraska. In 1902, Walter Devereux commissioned the creation of a silver punch bowl that was presented to the winner of the Rocky Mountain Championship, which was held each year at the Glenwood Polo Club. The Glenwood Polo Club was in operation from 1893 until around 1912.

SOMETHING FOR THE CHILDREN. In 1915, local celebrated Christmas in Glenwood by felling a spruce tree and placing it in the intersection of Eighth Street and Grand Avenue. On Christmas Day, jolly old Santa Claus arrived on the scene to hand out sacks of candy to the children, while everyone sang Christmas carols under the colored lights hung by the Glenwood Light and Water Company. Five years earlier, young George Johnson was hospitalized during the holiday season while suffering from incurable tuberculosis. As he lay in his bed at the newly built Glenwood Sanitarium, he worried that St. Nicholas would not find him on Christmas Eve. His nurses passed his concerns along to Louisa Schwarz and Myrta Mayes, and these two angels of mercy obtained a small tree and gifts to delight the young boy. When Johnson's nurses were sure he was sleeping, they placed the tree and gifts in his room. The next morning, he awoke to find that Santa Claus had not forgotten him.

Postman Extraordinaire. Mail carrier George Gibbons Hayes displays the motorcycle he used to carry mail to rural areas. The machine's top speeds ranged from 36 to 65 miles per hour, making mail delivery much faster. On Christmas Eve 1914, Hayes attempted to deliver the holiday mail to the mining camp of Sunlight by motorcycle. The weather had been mild, but as Hayes ascended to the camp, the snow became deeper, rendering the motorcycle useless. Steadfast in his determination to deliver the mail, he completed his journey on foot. After pushing through waist-deep snow, Hayes arrived at the Sunlight Company Store at 1:00 a.m.—he was 10 hours late and soaking wet. As he sat in front of the fire drinking hot coffee, he knew the children of the camp would have their Christmas because he had been willing to go the extra mile.

CELEBRATING 50 YEARS. Glenwood Springs celebrated its Golden Jubilee in August 1935. A highlight of the festivities included a parade in which a horse-drawn stagecoach carried some of the pioneers of the town. Local businesses placed historical items on display, a beef barbeque fed 3,500 guests, and a dance at the Hotel Colorado rounded out the celebration.

GRAND OPENING OF THE STATE BRIDGE. On April 27, 1891, a new bridge crossing the Grand River opened with much fanfare—the state bridge had been completed, and a celebration was in order. The grand opening was combined with the 72nd anniversary of the Independent Order of Odd Fellows. The residents of Glenwood Springs erected arches over Grand Avenue, placed evergreens along the street, and hung many yards of bunting for decoration.

MANDOLIN CLUB. Music clubs for children and adults were plentiful in the early days of Glenwood Springs. This group of young men is shown with guitars, mandolins, and even a fiddle. In 1905, the Glenwood Springs Mandolin and Guitar Club played for Pres. Theodore Roosevelt during his visit.

COMMUNITY GARDEN. The Boys Garden Club began with a mission of teaching farming practices and how to cultivate garden plots. In anticipation of food shortages during World War I, several Glenwood Springs men chose to work with young boys to teach them how to grow their own vegetable gardens. In 1916, the Boys Garden Club planted this community garden at Ninth and School Streets.

EARLY BOY BANDS. In July 1929, the Western Slope Junior Elks Boys Band (pictured above)—including 15 young men from Glenwood Springs—traveled to Los Angeles, California, and performed at the National Elks convention. After trekking to California by train, the boys met famed boxer Jack Dempsey, experienced an earthquake, and won the first prize ($100) as well as a standing ovation from the crowd. The band's interesting uniforms consisted of black-and-orange-striped blazers with gray-and-black-striped golf knickers, argyle socks, and newsboy caps. In the below photograph, members of the Glenwood Boys Band pose in front of the federal building at 901 Grand Avenue.

About the Frontier Historical Society

"Serving as the Living Legacy of our Local Life" is the mission statement of the Frontier Historical Society. The society was formed in 1963 by a group of Glenwood Springs residents who saw a need to save the past. Many of the pioneers were dying, taking their stories with them. At the time, the city of Glenwood Springs had been in existence for 78 years. The Frontier Historical Society was officially incorporated in the state of Colorado in April 1964. The society and museum were governed by a board of directors and volunteer staff. Soon after, a small museum was put together and housed in the basement of the Hotel Colorado. Sometime later, a small home located in the 800 block of School Street housed the museum and its collections. Every year, the collection grew, and housing it became a more of a challenge. In 1971, Stella Shumate passed away, leaving no heirs. Her attorney, a society member, had suggested that she consider leaving her home to the society for a new museum, and she did so in her will; the museum was moved to 1001 Colorado Avenue in 1972.

Today, the museum remains in the 1001 Colorado Avenue location. The first and second floors of the building are open to the public as museum exhibit space. The basement and renovated garage are used for storage of the most extensive archives in Garfield County, as a research facility, and for photograph collection storage and staff offices. The society collects and preserves artifacts and materials relating to the history of Glenwood Springs and Garfield County. It makes these materials available for research and interprets them through temporary and permanent exhibits at the Frontier Historical Museum and in off-site exhibits, publications, and educational programs. The society cooperates with other individuals and organizations to accomplish these goals. The museum staff includes a full-time director, one part-time registrar and archivist, and a part-time volunteer coordinator. The society has over 100 members and 60 volunteers.

Discover Thousands of Local History Books Featuring Millions of Vintage Images

Arcadia Publishing, the leading local history publisher in the United States, is committed to making history accessible and meaningful through publishing books that celebrate and preserve the heritage of America's people and places.

Find more books like this at
www.arcadiapublishing.com

Search for your hometown history, your old stomping grounds, and even your favorite sports team.

Consistent with our mission to preserve history on a local level, this book was printed in South Carolina on American-made paper and manufactured entirely in the United States. Products carrying the accredited Forest Stewardship Council (FSC) label are printed on 100 percent FSC-certified paper.

MADE IN THE USA